THE LOST MICHELANGELOS

THE LOST MICHELANGELOS

ANTONIO FORCELLINO

TRANSLATED BY LUCINDA BYATT

polity

First published in Italian as *La Pietà perduta* © RCS Libri S.p.A. 2010, Milano. This edition published by arrangement with Grandi & Associati.

This English edition © Polity Press, 2011

The right of Lucinda Byatt to be identified as translator of this work has been asserted in accordance with Section 77 of the Copyright, Designs and Patents Act 1988

Polity Press
65 Bridge Street
Cambridge CB2 1UR, UK

Polity Press
350 Main Street
Malden, MA 02148, USA

ISBN-13: 978-0-7456-5203-0

A catalogue record for this book is available from the British Library.

Typeset in 10.75 on 14 pt Janson Text
by Servis Filmsetting Ltd, Stockport, Cheshire
Printed and bound in the United States of America

The publisher has used its best endeavours to ensure that the URLs for external websites referred to in this book are correct and active at the time of going to press. However, the publisher has no responsibility for the websites and can make no guarantee that a site will remain live or that the content is or will remain appropriate.

Every effort has been made to trace all copyright holders, but if any have been inadvertently overlooked the publisher will be pleased to include any necessary credits in any subsequent reprint or edition.

For further information on Polity, visit our website: www.politybooks.com

To all restorers who never tire

CONTENTS

INTRODUCTION

This book describes the events surrounding the search for, and perhaps the finding of, two major paintings by Michelangelo Buonarroti which, for over a century, were thought to have been two drawings. Like many other stories of vanished or lost paintings, this, too, started with the finding of some unpublished letters, read almost by chance in the Vatican Library among the papers of Cardinal Ercole Gonzaga – son of Isabella d'Este and a major figure in the Italian Renaissance. However, this finding then led to some more unusual settings for historical research, including the Niagara Falls, Oxford, Parma, the archives in Dubrovnik, and finally New York, where key parts of our European history now seem to have emigrated.

However, perhaps the most original aspect of the story is that it offers an insight into the lives of extraordinary figures like Michelangelo Buonarroti, Vittoria Colonna and Reginald Pole, and also brings us closer to a group of passionate

reforming intellectuals, who challenged the censure of the Roman Inquisition for the sake of their utopian beliefs. Furthermore, precisely the two paintings we were looking for represented the most tangible and emotional expression of these beliefs. As if this were not enough, the story then took a new twist, to reveal the romantic and ill-fated loves of a group of women caught up in the rapid political changes of late nineteenth-century Europe.

In short, the story of the paintings boasts a plot that no fictional tale could hope to equal. This was the reason why I decided not to report the events in formal academic terms and to go further than is normally acceptable in such detached, dispassionate reports. I decided to include the excitement, the passion and the pure luck that underlie historical research – especially in a case like this, which not only concerns paintings of extraordinary value by none other than Michelangelo, but also uncovers individual stories, feelings and destinies. Moreover, I wanted to describe how the researcher must cope with all this while still steering a strictly methodological course.

Furthermore, the results of this research overturn established academic theories, theories that have been accepted as unassailable scientific constructions precisely because of the detachment of the methods used. I decided to challenge this detachment, and its alleged claim to guarantee knowledge, through the sincerity of an account that does not omit doubts and uncertainties. Indeed this account unashamedly admits the role played by chance, good luck – that irrational and uncontrollable helping hand without which no endeavour, even the most strictly scientific, would ever be successfully concluded. The decision to make room for what is normally left out of scientific reports, including the researcher's own tentative viewpoint, is, on the one hand, beneficial in terms

of broadening the content – and certainly it improves the narrative – but, on the other, it risks undermining the value of the research itself.

There are good reasons why specialists do not like talking about themselves or describing the paths that have led to their achievements. Above all, this threatens to make their work, and even their own personalities, seem more normal, more ordinary. It was a risk I was willing to take for two motives. The first was the excitement I had been fortunate enough to experience first-hand, and therefore I wanted to share this thrill and the accompanying emotions with a public outside the narrow field of specialists in my own discipline. The second, much more presumptuous reason was to use this frank, at times blunt, testimonial to start a debate on the mechanisms of subject specialisation, which often undermine rather than foster an expansion of knowledge.

This story is also one of unbelievable prejudice, which developed in academic circles from a mistaken reading of some documents that emerged from the Italian archives in the mid-nineteenth century. These documents consist of a few letters in which Vittoria Colonna comments on two paintings by Michelangelo using terms which are perfectly appropriate, but which do not conform to the critical tradition based on Vasari's account. In consequence, according to this tradition, on this occasion Vittoria, an accomplished and eloquent poetess who carefully weighed every word, is thought to have confused 'painting' with 'drawing'. Incredible as it may seem, this art historical tradition became so obsessed with this distinction that it even went so far as to deny the existence of the paintings. However, new documents, which have emerged in a different but equally relevant context, have given renewed impetus to the hypothesis that these paintings did indeed exist. In the meantime, the stubbornness with which art

historians perpetrated this elementary mistake for nearly a century can only be explained by their excessive reliance on a self-referential approach.

This way of reinforcing prejudice through the ritualised use of academic writing and methods encouraged me – once I had reported these findings to a scientific meeting – to experiment with a new form of language and a new way of communicating, at least for a scholar. The approach is certainly not without pitfalls. Above all, it exposes the ordinariness of the author's personality: by stripping away terminology and tested procedures, you also remove all protection against criticism, running the risk that the scientific results are subject to attack and accusations of oversimplification, if not exhibitionism. But it is a risk I am willing to take, because at this stage in my life a genuine account of the journey is worth far more than the scientific results to which the journey has led.

1

NIAGARA

A dense milky white mist rose behind the trees. As the sunset faded into darkness, the coloured neon lights grew brighter with every passing minute, especially on the other bank, the Canadian side. From the window on the twentieth floor of the hotel the enormous, flat horizon vanished into nothingness, conjuring up a vision of the endless forest stretching thousands of kilometres as far as the glaciers of Alaska. Inside the Seneca Casino, the atrium has twenty-metre-high walls of coloured marble, some with water flowing down them to create a discreet yet audible ripple, a foretaste of the thundering roar of the world's largest and most famous waterfall. The hotel's design is reminiscent of the Empire State Building in New York, but only in that 'nouveau' way that combines the European taste for gold and precious marble with that uniquely American penchant for massive intersecting straight lines, curves and superfluous embellishment. People were wandering across this space, which was as wide as an Italian

piazza, without even glancing at the tomahawks and spears, or at the huge feathers hanging from the ceiling, in tribute to the Native Americans who inhabited this area until two hundred years ago. Seneca: it took me two days to understand why a casino beside the Niagara Falls, on the border between Canada and the United States, should be named after such a stern philosopher. In the end I discovered it was nothing to do with him; the name came rather from the Seneca tribe who used to live in this area around the Falls. The enormous hotel is built around a hangar as large as Piazza del Popolo and filled with bright lights, gaming tables and flashing slot machines. It is a world of childish wonder, designed to attract unhappy, probably lonely adults and inveigle them into procuring plastic tokens and glittering fiches to buy back the dreams they have lost along the way.

Unaccustomed to the scale of this spectacle, I found myself being lulled into a daze, but not without a niggling sense of unease. It was eleven at night local time, but for me it was five in the morning and I had not slept a wink. After leaving Rome at nine the previous morning, I had changed planes in New York for Buffalo and from there took a taxi to this astonishing world. For the first time, but also for the last, I was overwhelmed by doubt: had this all been an enormously expensive waste of time? Why had I come here, of all places, looking for Michelangelo? What could possibly link the Seneca Casino to that genius, Michelangelo Buonarroti? This name, which for twenty years has been part of my daily life, is linked to other, less neon-illuminated buildings, like the Basilica of San Pietro in Vincoli in Rome, where the scaffolding I used to work on was lit by clip-on spotlights; or to the Vatican Archives, where the light is always dim; or to the fragile paper sheets with their furious pencil scorings in the Casa Buonarroti in Florence. Or even to the ceiling of the Sistine Chapel, where the vastness of

the scaffolding and the violent beauty of the iridescent colours seemed far removed from this unreal setting. On the stage of this brightly flashing theatre I could not even conjure up the artist who has become part of my every waking moment, as well as of my memories. Tiredness made me feel stupid and guilty. If I had not been so exhausted, I would have left immediately and caught the next flight back to Rome; but, as luck would have it, I only went upstairs to my room and fell asleep.

I woke before dawn. Outside the window, the faint light in the sky was almost absorbed by the enormous cloud of white mist hanging over the Falls. It was a beautiful sight, perhaps coloured by my love for artists like Edward Hopper and Winslow Homer; but the landscape could not have been more American and more sublime. Low, painted brick buildings lined the streets, which looked too wide because there was not yet much traffic this early in the morning. The road signs painted on the tarmac in clear colours had all the precision of an electric circuit.

This was my impression of Niagara Falls, together with the rather snobbish sensation that the Falls themselves were a typically 'American' attraction, whose fame owes more to size than to beauty, to a taste for what engenders awe rather than wonder. Standing in front of the window and looking at the distant orange sun rising above the forests and the Atlantic Ocean, I was happy that Niagara had unexpectedly become part of my destiny, part of the search for fragments of a story that could never be wholly reassembled because it is too big and too important; a story that is rewarding merely for the fact that it has come to light at all.

The man who had urged me to make this journey had been thoughtful enough to arrange a meeting at six in the morning. He of all people was well aware of the problems caused by jet lag, given that he had been a fighter jet pilot who had later

transferred to civil aviation. He had written to me months earlier, not directly – at least to start with – but through a German professor he had met. After my books on Michelangelo had been published and translated into several foreign languages, I had become something of an authority in the field of Michelangelo studies, also because, apart from the fact that I was an art historian, my work as a restorer placed me in that special category of experts once called 'connoisseurs'. By this, I mean those who not only study art as a theoretical subject, but also acquire practical knowledge, derived not from photos but from dealing intimately with the objects, every day. This was why the former pilot and the German professor had sent me an email with an attached photo. Indeed, they had gone further: the photo was not of a painting; it showed a detail of the underdrawing revealed by infrared reflectography – an imaging technique that penetrates the top layers of paint to reveal what is beneath, which may be an underdrawing or details covered by later painting. They were relying on the fact that a restorer, a specialist in artistic techniques, would have seen in that drawing things that would normally escape an art historian, given the latter's lack of familiarity with painting methods. And they were right.

Anyone whose name becomes reasonably well known in a particular field is swamped by unsolicited requests for expert advice, judgements or comments on works of art. These are almost always works of no consequence because, generally speaking, the usual channels – namely an estimate, or an opinion from a reputable auction house when a work of art first emerges – operate quite well. Moreover, these requests are frustrating and often demanding, because internet makes access so easy. It is astonishing how many people convince themselves they own a Michelangelo or a Raphael, inherited from some old aunt or picked up from a dealer in the ill-

founded belief that some dealers, even antiques dealers, have less of an eye than they do. I once visited a bank director who was convinced he owned a *Crucifixion* by Michelangelo. The illusion had even been encouraged by a well-known Roman curator whose insight I had no reason to doubt, but whose opinion was, in retrospect, perhaps intentionally misleading. Having accepted to see the *Crucifixion* and finding myself looking at a small late nineteenth-century painting in a blatantly pre-Raphaelite style, I felt so embarrassed that I had to fake sudden illness and make for the door without further explanation.

Since then, I had even stopped opening any emails that laid claim to miraculous finds. But this one from America was different, not least because it is not every day you get a chance to see an underdrawing using sophisticated imaging apparatus. The photo had me glued to the screen. It showed the bust of a Madonna fastened with a band on which there was a pin decorated with the head of an angel or cherubim with little wings sprouting from its shoulders, as is usual in the iconography of the Virgin Mary.

I immediately noticed the contrast between the head and the folds of the tunic. The folds had been copied from the dusty outlines of a preparatory drawing. In other words, when the contours of a drawing are pricked and then pounced with a bag full of charcoal dust, the dust passes through the holes, to form a row of tiny dots on the surface of the panel, which has been prepared with a layer of gesso and a protein binder. The artist then joins the dots by using a brush dipped in a watery paint solution and re-creates a copy of the drawing he intends to paint on the panel, as it was on paper. Of course, the strokes used to reinstate the drawing on the panel are more or less decisive and more or less confident depending on the artist's talent. But, equally, the information transferred

from a drawing onto the panel can tell us a lot about the artist's skill. A confident artist will only reproduce the essential information, leaving the composition to be completed during the next phase. In the photo I was looking at, the underdrawing of Mary's tunic seemed confident and essential, but what astounded me was the fluency of the cherubim's portrait. The brushstrokes varied with such smoothness that it was evident the head had been drawn freehand, without an underdrawing. Even at this preparatory stage, it was extremely beautiful and particularly expressive. This alone was enough to justify answering the enquiry and asking the sender to send me a photo of the painting and any information about its history.

As I wrote, I tried to maintain a polite but disinterested tone; and I certainly never imagined that behind the computer screen, on the other side of the world, there was a former air force pilot who had dedicated the last ten years of his life to researching this painting, continuing a painstakingly documented family tradition that had lasted, without a break, for over a century. On the other hand, the pilot could certainly not have imagined that two years before, while sitting in the Vatican Library and leafing through a bundle of manuscript letters that I had already consulted four years earlier, I came across a brief but illuminating letter, which had initially escaped my attention. As I ran my eye across the ink characters, written as they had been – with a quill cut and scored with a razor-sharp blade four hundred years earlier – on the morning of 11 June 1546, my heart began to pound.

As always at moments of great excitement, I pushed back my chair and stood up. The Vatican Library gives all readers a wooden ruler with smoothly rounded edges to use as a marker on the precious manuscripts, so as not to damage the delicate rag paper manufactured laboriously in the paper mills of Fabriano or Bologna. That morning, I rested the ruler

carefully on the bundle of letters. Noiselessly and trying to match my pace to the hushed tread of the theology scholars gathered around the sixteenth-century display cases containing manuscripts that were thousands of years old, I made my way into the small internal courtyard that joins the Archive to the Library.

Housed somewhat incongruously in the old nymphaeum built by Pope Sixtus V is a café where, among the ruined stuccowork, the unscholarly appetites of those working in the reading rooms can be held in check by filled pizzas, a speciality of Rome. The small garden is surrounded by a brick wall on which you can still see the layer of 'colla di carbone', or mortar darkened with wood charcoal, applied between 1584 and 1590 by Cherubino Alberti. Smoking is permitted in the garden, even if the only ones who still do it are the cleaners. But that morning I had to smoke a couple of cigarettes before my heartbeat returned to normal. When I felt ready to copy the letter onto my laptop, I went back into the reading room.

2

MANTUA, 11 JUNE 1546

On the morning of 11 June 1546 Cardinal Ercole Gonzaga was sitting in his study in the palace at Mantua, going through his correspondence and writing the few lines that now lay before me in the Vatican Library. He was surrounded by the women, gods and men, handsome and happy, painted by Giulio Romano, but their presence did nothing to mitigate the heat of summer, which was all the more stifling because of the Po River nearby. Nor could these extraordinary frescos relieve the fatigue of a life devoted to the rule of his state and to what had become the turbulent rule of the Church.

As the son of Francesco II Gonzaga and Isabella d'Este, the most elegant woman in late fifteenth-century Italy, Ercole had grown up with an appreciation of art that had turned Mantua into one of Italy's most refined princely courts. In keeping with common practice among Italy's leading dynasties, he had been elevated to the cardinalate by Pope Clement VII in 1533 and had moved to Rome. However, after 1534,

when Cardinal Alessandro Farnese was elected as Pope Paul III, the political climate became increasingly oppressive. In search of a principality for his son, Pierluigi Farnese, the pope had set his sights on the Duchy of Urbino, which was ruled by Ercole's brother-in-law, Francesco Maria della Rovere. Ercole's older brother, Federico, had succeeded to the Duchy of Mantua but had died shortly afterwards, in 1540. As a result, Ercole had taken his brother's place and returned to Mantua shortly after the latter's death. In his dual role as prince of a secular state and prince of the Church, Cardinal Gonzaga found himself dealing with one of the most acute episodes in Italian history: the crisis of the 'Reformation' within the Roman Church. Because the Duchy of Mantua lay on the crossroads between the Lutheran world and that of conservative Catholicism, and, moreover, because Mantua was traditionally allied to Emperor Charles V, Ercole became one of the most committed and influential men on this hotly contested Italian chessboard.

After a period of youthful high spirits during which he had fathered a daughter, the cardinal developed a deep and sincere faith, which very soon brought him into contact with a reforming group searching for a way out of the religious crisis, one that would reconcile Catholicism with the Lutherans' theological demands, yet retain the primacy of Rome. While the Lutherans affirmed that true Christian redemption lay in the cultivation of a 'living' faith that linked the believer directly to God, without his trying to buy it through liturgical practices, the Church of Rome, whose temporal power was based precisely on the management of such practices, did not intend to watch as its power was undermined by the attacks of the reformed theology. The group of Catholic reformers, who were already known as the *spirituali* by contemporaries, shared the Lutherans' conviction that

salvation did not depend on good works, namely on conforming with ecclesiastical rites, but on a sincere faith in Christ and in the sacrifice he had made through his own death. However, the *spirituali* also attempted, at least in part, to redeem the value of good works, and hence the primacy of the Church of Rome, by arguing that a good Christian life, which also included the practice of some liturgies, could illuminate the profundity and sincerity of faith.

From 1541 the leader of this reforming group was the English cardinal, Reginald Pole, King Henry VIII's cousin. Pole attracted into his orbit lay members of outstanding sensitivity, like Vittoria Colonna, a Roman noblewoman and a renowned poetess who had been married to the Marchese of Pescara. Other influential members of the group had close family ties with Cardinal Gonzaga: they included his sister, Eleonora Gonzaga, Duchess of Urbino, and his cousin's wife, Renée of France, Duchess of Ferrara, one of the most restless figures of the century on account of her uncompromising religious opinions. Renée caused considerable trouble to Ercole by publicly professing beliefs regarded as scandalous by the official Church; she also offered hospitality to several heretics banned by the Church of Rome, and even allowed them to preach in the city churches. The various reforming currents in Italy were on a collision course and the boundaries between them were still very fluid, given that no council had yet proclaimed a universal truth recognised by theological dogma; by the mid-1540s, however, the council was imminent, and Ercole and his companions knew that they had already attracted suspicion and that the Roman Inquisition had them in its sights.

The situation had become explosive after 1542, when the preacher Bernardino Ochino, summoned to Rome by the Inquisition for the heretical content of those sermons that

sent Ercole and his group into ecstasy, had escaped to Switzerland, thereby abandoning all pretence and openly siding with the Lutherans. In his sermons and writing, Ochino had always openly praised the redeeming role of Christ's sacrifice, placing faith in this sacrifice before the observance of liturgical laws. Ochino's apostasy caused trouble for all his friends: for Vittoria Colonna, for Renée and, above all, for Ercole, who had protected him and celebrated him as a spiritual leader. Moreover, according to informers in the Roman Curia, Cardinal Gonzaga himself had actually helped him to escape over the border. Certainly Gonzaga's letters from this period reveal the caution of a man aware that he, too, might be hunted down and spied upon; and, above all, aware that the final outcome of the reform movement was still very uncertain. The letters dating from the summer of 1546 were particularly prudent. Six months earlier, in late 1545, the council had opened – not far from Mantua, in the small town of Trent, a convergence point between Germany and Italy. It was chaired by three papal delegates. The hopes of the reformers were pinned on one of those delegates, who was none other than Cardinal Reginald Pole. Gonzaga believed that a theological reconciliation would lead to a revival of the faith, while the Inquisition viewed it as a concession to Lutheran heresy.

From December 1545, therefore, the real battlefield in this religious conflict shifted to Trent. As on every battlefield, intelligence was crucial in revealing the web of alliances and the objectives of the various factions. Pole and the other two papal delegates, Cardinals Marcello Cervini and Giovanni Del Monte, sent daily reports to the Curia in Rome. Alongside this official information, as in every self-respecting war, there was an active network of informers and collateral intelligence, which offered the pope a much blunter but more truthful

picture of the clash taking place. According to this intelli-
gence, a very influential group of cardinals and bishops in the
council were completely in tune with the Lutherans on theo-
logical grounds and were manoeuvring to approve a decree
that, broadly speaking, would accept the Lutheran idea that
salvation of the soul depended on the pre-eminent value of
faith rather than on good works. This would have completely
transformed the Church, moving it towards a more spiritual
and less material realm. In the summer of 1546, this decree
was at the very centre of the clash. If the council had accepted
the pre-eminent value of faith for redemption, Catholics all
over the world would have felt much less constrained to
follow ecclesiastical liturgies, and even the celebration of mass
would have been called into question.

According to secret intelligence, the members of this par-
ticular group were not limited to Cardinal Pole, whose
pro-Lutheran stance had been known to the Inquisition for
years. Among the first episodes that had raised suspicion was a
devotional booklet referred to as *Il beneficio di Cristo*, which had
been abridged by Pole's circle of fellow *spirituali* in Viterbo
and exalted the value of faith over and above works. Although
the authors took the precaution of printing it anonymously in
Venice, the book had rapidly become a best-seller, forcing the
Inquisition to censure it and actively persecute its editors. At
Trent, Pole was supported by Cristoforo Madruzzo, Bishop of
Trent, and by Cardinal Giovanni Morone, Bishop of Modena,
both of whom were already being monitored by the Inquisition.
There was also a large group of bishops sympathetic to the
reformers' demands. Among these was the Bishop of Fano,
Pietro Bertano, who had been appointed by Ercole Gonzaga
and dispatched to Trent – not only to keep the cardinal
informed of the daily affairs of the council, but to act as a
spokesman for the requests that Gonzaga passed to him at

private meetings and in cautiously worded letters. Bertano was very close to Pole in the struggle at Trent: his allegiance was reported by the secret informers and can also be seen in the dozens of letters he wrote to Gonzaga. In one of these, sandwiched between paragraphs on biblical canons and penitence, St Paul and papal authority, Bertano unexpectedly made an offer to Ercole Gonzaga on Cardinal Pole's behalf. On 12 May 1546, Bertano wrote to Gonzaga:

> Monsignor Pole has heard you desire a Christ by Michelangelo and he has asked that I secretly enquire as to the truth of this wish. Indeed, given that he has one by the hand of the said artist, he would be pleased to send it to you, but it is in the form of a Pietà, although you can see the whole body. He says this would not be a great sacrifice because he could obtain another from the Marchesa of Pescara.

This letter reveals that Michelangelo too had a role to play in the battle at Trent: although a private gift, his art was deemed more capable of rallying the front-line reformers than any powerful secret weapon. Gonzaga's reply came by immediate return, being written on 21 May and dispatched to Trent:

> Monsignor mio, as a brother, if you could let me have that painting of the image of Christ belonging to the Most Reverend Pole solely so that I could arrange for Messer Giulio Romano to copy it and then return it to you, it would be a most rare opportunity. If indeed the cardinal would be so courteous as to agree to this, I tell you freely I do not intend him to deprive himself in any way, given that I cannot imagine a better place for Christ's image than in the hands of one who carries Him sculpted in his heart through faith.

But the painting was delayed, and Ercole grew impatient. He had met and deeply admired Michelangelo during his time in Rome, and his fulsome praise for the statue of *Moses* was particularly welcome to the artist. When the *Last Judgement* was unveiled in the Sistine Chapel in November 1541, it had scandalised many Italian prelates, but Ercole was unshaken in his admiration. Through his ambassador in Rome he had desperately tried to find a drawing, an autograph fragment by Michelangelo.

Like mother like son: while Isabella had pestered Leonardo and Raphael for autograph works that she could add to her collection, her son Ercole was on the lookout for anything by the hand of Michelangelo. In particular, Ercole would have paid any price to have a 'Christ', both because his faith was focused on the veneration of Christ and because he had heard admiring comments of another Christ painted by Michelangelo, which the Marchesa of Pescara, Vittoria Colonna, had shown Ercole's ambassadors in Rome during a courtesy visit. It was initially through Vittoria that Michelangelo had approached the *spirituali*, before he became one of the most powerful interpreters of their devotion. When Pole left for Trent to attend the council – which Vittoria and the others hoped would produce a renaissance of faith throughout Europe – the marchesa had promptly given him the *Pietà* painted for her by Michelangelo. She was certain this small image alone would bolster Pole's spiritual strength in the difficult task ahead. Now Pole was offering it as a gift to Cardinal Gonzaga, his invaluable ally in the struggle for Reformation. For Pole, this iconic painting had more in common with a holy relic. It confirmed an intimacy of faith that was more precious, more important than any worldly possession, and in this it differed in every respect from other works of art on the market. However, Ercole Gonzaga,

Emperor Charles V's most powerful ally and one of Italy's foremost princes, deserved to be treated well, particularly in view of Pole's highly ambitious agenda for the council. Cardinal Pole had convinced himself that he could get another painting from the marchesa, either because she already had one in her possession or because he was confident she could persuade Michelangelo to copy the painting.

Gonzaga was so pleased with this offer that he reciprocated Pole's generosity by stating that he could not remove the painting from the man whom he regarded as a living saint. Instead, he would be content for Giulio Romano, Raphael's pupil and the Gonzaga court artist in Mantua, to copy the painting. This would mean keeping it for a few months, then returning it to the English cardinal. But by 11 June the painting had still not arrived; and that morning, as the Cardinal of Mantua sat down to deal with his state correspondence, he found time to dash off a heart-felt but concisely worded note, which was polite but firm:

> The sooner Your Lordship sends me the painting belonging to the Most Reverend Cardinal Pole, the more delighted I shall be to arrange for it to be copied immediately and returned to His Most Reverend Lordship.

Sadly, Ercole's wishes were never fulfilled.

That summer the temperature rose to suffocating levels even in the mountains around Trent. Pole, Bertano, Madruzzo and the other representatives of the 'evil plant of Lutheran heresy', as the Inquisition would shortly describe them, realised the battle was lost. The decree on Justification, around which the whole question of reconciling the Lutherans with the Church of Rome revolved, had failed to gather sufficient support to ensure the outcome the *spirituali* so keenly desired.

As the conflict entered the final bitter stages, the accusations of heresy became increasingly outspoken.

The situation in early August was outlined bluntly in the letters from one of the participants at the Council, the Bishop of Crete, Dionysio Zanettini, who reckoned that the efforts of the reforming Catholics were now pointless. Lutheran truth and Catholic truth, he wrote, were as far apart as darkness from light, as Christ from the demon Belial. It was an image in which darkness and the devil were of course concentrated north of the Alps. Pole left Trent and the impending show-down, offering ill health as a feeble excuse; he travelled to Padua, and then, in early October, to Rome. From Ercole Gonzaga's saddened letter we learn that Giulio Romano died in early October, leaving the cardinal aggrieved as if he had lost a brother. If Gonzaga ever actually managed to have the painting copied, it would not have been by Giulio. Another artist may have done it: a much more mediocre one, like Fermo Ghisoni perhaps, who was paid to copy some paintings from Michelangelo. More probably the matter was set aside as Ercole returned to the hard task of ruling the state, although he continued to admire Michelangelo. Like the rest of us, princes, too, treasure their childhood memories; and for Ercole this also meant the warmth of the house where he grew up with his beloved sister Eleonora. The inexorable need to bolster dynastic power had also sacrificed her to a state renowned more for its troubles than for its success. Her husband, Francesco Maria I della Rovere, was a man given to violence more than to love, and he left her with a venereal disease from which she was now slowly wasting away.

Like her brother, Eleonora too drew strength from that pure new faith. This may perhaps explain why the only rare glimpses of sentimental abandon in Ercole's twenty-year-long correspondence are when he writes to his adored sister. He

addresses her with a tenderness that reveals the suffering of a life sacrificed to power: he valiantly attempts to quash the uncertainties that he, of all people, cannot afford to show.

> ... if my name doesn't displease you as it pleased the Lady our Mother, oh sister, I have grown so white-haired. Every hour that passes seems like a hundred years ... I now long to remove your bonnet and see which of us is whiter, and on that note I recommend myself to you.

For a second, the mask of power slips off the face of both cardinal and duchess: looking at each other, brother and sister see themselves reflected in each other's eyes. Behind the rulers, we catch a glimpse of children remembering their mother Isabella. But time has passed, and the colour of their hair, carefully concealed beneath their caps, has faded together with their childhood dreams.

3

SEPARATING FACT FROM FICTION

There were many reasons for my euphoria at the sight of the yellowing sheet of paper that had remained hidden for four hundred years in the Vatican Library. After so many years, I was the first to read it, or at least to set it in context. The other two letters – from Bertano to Gonzaga and from Gonzaga to Bertano – in which the former offered the painting on Pole's behalf, and the latter then accepted the offer, but only to copy the painting – had already been found in the early twentieth century and in the early 1990s respectively. However, apart from the frisson among specialists that generally accompanies any new document directly or indirectly concerning the most shadowy genius of western art, they had not caused much of a stir. The main reason why these documents had not seemed important was that a fuller understanding was impeded by the account given by Giorgio Vasari, Michelangelo's first biographer.

Giorgio Vasari was an ambitious painter born in Arezzo in

1511. Alongside his career as an artist, he cultivated that of historian of the new Italian arts, collecting information and documents of all kinds concerning painters, sculptors and architects from the thirteenth century onwards. This resulted in a monumental treatise, which modern historiography has used as the foundation of the study of Italian art. Vasari knew Michelangelo well, and the two men met occasionally. However, it is often overlooked that these meetings took place above all during the last part of Michelangelo's life, when Vasari acted as the go-between between the artist and Duke Cosimo de' Medici.

Vasari was in Rome between 1544 and 1546, and towards the end of that time he was appointed by Cardinal Alessandro Farnese to paint the hall in the Palazzo della Cancelleria, which became known as the Sala dei Cento Giorni because it was painted in a hundred days. Vasari may have had an opportunity to meet Michelangelo in person then, because he reports that he accompanied Titian to visit Michelangelo between the autumn of 1545 and the spring of 1546. It seems likely that the meeting took place in the Pauline Chapel in the Vatican, where Buonarroti was working, since it was difficult to gain access to the artist's house. Moreover, Vasari would not have discovered what the artist was working on if he had seen him at home. On the one occasion when Vasari had barged into Michelangelo's studio while the elderly artist was working on the Bandini *Pietà*, Michelangelo was so annoyed that he knocked over a lamp to prevent Vasari from seeing his work. We are told this by Vasari himself. Furthermore, Vasari was in the pay of Cosimo de' Medici, whom Michelangelo regarded as a tyrant and a usurper of Florentine liberty. In the years between 1540 and 1550, Michelangelo had still not lost hope of seeing the Medici chased out of Florence and he stayed well clear of any Medici supporters, also because his

nephew had warned him that his friendship in Rome with the last of the indomitable Tuscan republicans was well known and heavily criticised on the banks of the Arno. Therefore it would have been very difficult for Vasari to approach Michelangelo's more intimate circle and to see the small painting on which the artist had been working for some months in the inviolable secrecy of his own home.

On returning to Florence in the autumn of 1546, Vasari collated the material he had collected in Rome, including the information on Michelangelo. He had gathered much of it from the circle of Cardinal Farnese and from the latter's most trusted and learned advisor, Paolo Giovio, who helped Vasari to revise the proofs of the *Lives* before they were printed.

Michelangelo could not let it be known in Farnese's circle that he had painted a picture for his friend Vittoria Colonna. This was partly because of the ambiguous boundaries defining even then their common cause, and partly because the powerful cardinal, arguably Italy's most influential figure, had repeatedly asked Michelangelo for a small, autograph work which the artist had stubbornly refused to provide. There were good reasons for Michelangelo's behaviour: he received so many requests, from so many powerful patrons, that to fulfil some and not others would certainly have created problems. But in spite of Michelangelo's obsessive discretion, in 1546 Giulio Bonasone, a famous engraver from Bologna who had moved to Rome, printed a *Pietà* drawn by Michelangelo. It is possible that Michelangelo himself gave Bonasone the preparatory sketch he used for the painting, or it might even have been his friend Luigi del Riccio, to whom Michelangelo was heavily indebted – because Luigi had cared for him and had certainly saved his life during a serious illness a few months earlier. Luigi was a Florentine who worked for the Strozzi in Rome, and he shared Michelangelo's enthusiasm

for the republic, as well as his equally fervent passion for handsome youths. In February or March 1546, Michelangelo wrote a furious letter to Luigi:

> Anyone who saved me from death is also at liberty to dishonour me, but I don't know which is the heavier burden, dishonour or death. I pray and beseech you, however, for the sake of our true friendship – even if it is not apparent at present – that you destroy that print and burn any copies that have been printed. If you want to profit from me, don't use others to do so, and if you cut me into a thousand pieces, I will do the same, not to you but to your belongings.

Gaetano Milanesi, who was the first to publish this letter, made the connection between it and the Bonasone engraving: 'It seems', he writes, 'that this letter about a print of Michelangelo's painting may perhaps refer to the *Last Judgement* in the Sistine engraved by Enea Vico, or perhaps to one of the prints by Giulio Bonasone.' Of course, the *Last Judgement* was a public work over which Michelangelo had no control, while the small painting of the *Pietà* for Vittoria was a private gift, and, as such, jealously guarded. Michelangelo could have given the preparatory sketch for the painting to Luigi del Riccio; but, because the pricked lines of pouncing holes made it unpresentable, his friend may have thought he was doing Michelangelo a favour by asking Bonasone to make an engraving. All this is mere conjecture, because Michelangelo's complex personality alone makes many of his actions incomprehensible. His motives became even more unfathomable during this period, when, in addition to the strain of political frustration, this diffident but impulsive individual was well aware that he had become associated with a dangerous devotion, tinged with heresy. As we will see

shortly, Bonasone's engraving and the later engraving made by Beatrizet are so faithful to Michelangelo's preparatory sketch that it seems probable they were copied directly from it.

At all events, in 1546 an engraving of Michelangelo's *Pietà* was produced in Rome by Bonasone. Four years later, Vasari asserted that Michelangelo had drawn a *Pietà* for Vittoria Colonna. 'Michelangelo', he writes, 'also deserved that the divine Marchesa of Pescara wrote to him and composed works praising him; and he sent her a most beautiful drawing of a *Pietà*, which she had requested.' Whether Michelangelo was taken by surprise by Bonasone's engraving and tried to silence the news by spreading the rumour of his drawing for Vittoria, or whether he had indeed given the preparatory sketch to the engraver and did not want to reveal the existence of the painting, it seems highly likely that Vasari was completely unaware of the newly finished painting, which Pole took with him to Trent.

Vasari made other, much more important mistakes about Michelangelo's work of this period, the most obvious one being the subject matter of the paintings in the Pauline Chapel, the papal chapel that was the focus of public attention in Rome. Vasari stated that Michelangelo was painting the *Consignment of the Keys to St Peter*, when in fact he was painting the *Crucifixion of St Peter*. An error of this magnitude was too glaring not to be corrected in the second edition of the *Lives* (1568), but the mistake over the *Pietà* was not significant enough to receive similar treatment. Two convictions therefore stem from Vasari's account: that Michelangelo gave Vittoria a drawing rather than a painting; and, more generally, that, after the Doni *Tondo*, Michelangelo no longer painted movable works. Indeed, this latter hypothesis appears all the more probable in view of the scorn shown by

Michelangelo for those who treated art as *'opera di bottega'* [an artisan trade based on collaboration], even if he had done precisely this in the early years of his career. Once he had become famous and was able to fashion his own myth, he tried to give his artistic output an aura of creative nobility, setting it apart from that of colleagues who were forced to work in a business-like 'workshop' manner in order to make ends meet. However, this too was a myth because, right to the end of his life, Michelangelo always ensured that he was paid for every artistic commission. Of course, for the past decade or so he had been in a position to turn down any commissions of a purely artisan nature and to dedicate himself to his major patrons in return for equally significant financial rewards. This also explains why the drawings and paintings for Vittoria and for Tommaso Cavalieri, a young Roman nobleman who dabbled in architecture and with whom Michelangelo was hopelessly in love, were regarded as gifts, and not as commissions, both by the artist and by the recipients. More specifically, they represented an intellectual exchange – one which, in the case of the young Roman nobleman, expressed love, and in the case of the noblewoman expressed a community of faith and religious passion that was as profound as any amorous attachment. But, while the dynamics of the relationships between Michelangelo, Vittoria and Tommaso sank into oblivion as soon as the three participants died, Vasari's printed account in the *Lives* acquired the authenticity of an original source, paradoxically surpassing even the testimony of genuine documents that have emerged from the archives over the years.

Immediately after Michelangelo's death, his passion – whether it was his erotic desire for the young Tommaso or the heretical devotion that he shared with Vittoria for Christ's sacrifice – was seen as a potential source of scandal, to be

purged from the hagiographic accounts. The first extensive censure of the artist's homosexual passion was carried out by his nephew, Michelangelo the Younger, who changed the word endings in the sonnets from male to female. But it was Michelangelo himself who erased any trace of his religious passion by destroying Vittoria's numerous letters as well as the sonnets she had sent him, of which he still possessed large numbers in 1552, according to a letter written at the time. Some of the letters that survived this purge and reappeared in the mid-nineteenth century question Vasari's account and throw light on a more likely sequence of events. A series of five letters from Vittoria to Michelangelo was found and published in 1866 by one of the greatest Italian experts, Marchese Giuseppe Campori. There Vittoria writes ecstatically about the paintings she has seen:

> I have received your letter and seen the Crucifixion, which certainly crucified in my memory all the other paintings I have ever seen [. . .] And in this situation I do not know to serve you in any other way except by praying to this sweet Christ, whom you have painted so well and so perfectly, and beseech you to command me as your own in the future and in everything.

Vittoria's language and her artistic appreciation are so refined that it seems unthinkable to suggest she was actually looking at drawings and not at paintings. Yet, for some inexplicable reason, leading art historians – certainly the most authoritative, if not always the most acute – have affirmed that the marchesa was indeed referring to drawings and that, in Italian and in the vocabulary of the time, the verb *dipingere* [to paint] is synonymous with *disegnare* [to draw], and the noun *quadro* [painting] synonymous with *disegno* [drawing]. This is an

extraordinary example of intellectual prejudice. Because Vasari is regarded as the founding father of history of art as a discipline, a massive operation was commenced that aimed to manipulate the interpretation of the documents in a way that would not undermine his authority. The question became even more complicated over time, because Vasari's version was espoused by some of the most influential academics of the twentieth century. Therefore any suggestion that Vasari's authority should be reassessed meant questioning the 'academic' truth they and other experts had built on throughout the century. Since academic authority is based on adherence to theories that have been examined and consolidated by academic studies, few have the courage to stand out against a 'truth' that has been approved over time out of prejudice more than on the basis of philology and real documentary support. Objections are therefore discredited, even when they are based on new documents that come to light.

The letter from Bertano to Gonzaga was published in 1907, but the greatest expert on Michelangelo, the historian Charles de Tolnay, affirmed that Bertano was offering Gonzaga a drawing, not a painting, even if it might seem incongruous that Gonzaga wanted to ask Giulio Romano to copy a drawing. Then in 1991, when Gonzaga's reply was found in which he mentions a '*quadro*' ['painting'], inexplicably no one had the courage to question the accepted version of events. Indeed, I might not have done so myself, had I not had first-hand experience – while working on the restoration of Julius II's tomb from 1998 to 2003 – of how unreliable the critical 'tradition' on Michelangelo Buonarroti can be, owing to the wealth of studies on the artist.

During the restoration it was discovered that the famous statue of Moses had been completely reworked in order to change the prophet's position. There were evident signs of

these changes on the statue, but they had escaped the notice of all modern experts. This surprising discovery prompted me to adopt a degree of caution when dealing with academic or traditional truths that do not stand up to close documentary analysis – and by document I mean the work of art itself, which, to those who know how to read it, sometimes talks more clearly than written words. The consequences of this finding were enough to convince me that a fresh examination of Michelangelo was not only possible but necessary, although many were quick to claim that there was nothing more to be said about the artist. In the meantime, modern historical research was revealing, independently and with increasingly less reticence, that Michelangelo had played an active role in the group of reformers surrounding Pole and Vittoria Colonna. Indeed, while Cardinal Gonzaga's first reply to Bertano – in which the cardinal accepted the *quadro* – could be brushed aside as a misunderstanding (Bertano offers Gonzaga a drawing [*disegno*], but Gonzaga thinks it is a painting [*quadro*]), the discovery of the second reply, dated 11 June 1546, dispelled any remaining doubts. In this second letter Gonzaga insistently asked for the *quadro* that Pole had taken to Trent, since he wanted Giulio Romano to copy it. Both sets of correspondence – Gonzaga's and Vittoria's – back each other up, showing that the only ambiguities lie in Vasari's account. There is no doubt that Michelangelo produced at least two small devotional paintings.

4

A MOVABLE PANEL PAINTING

Confirming the existence of a painting through documentary sources is one thing, but finding it is quite another. Above all, when copies of the painting have been spread all over the world. Numerous versions exist of the Bonasone–Michelangelo *Pietà*, many by Marcello Venusti, a painter who collaborated with Michelangelo. But there was something special about the *Pietà* I had been shown in the email, something striking that had disturbed me, although I could not exactly explain what. It had prompted me to cross the Atlantic, and now it kept me in the huge atrium of the Seneca Casino in Buffalo, staring at the water that ran over the coloured marble walls as I was surrounded by thousands of slot machines. It was barely six in the morning, the sky was still dark and, now and again, couples or a lone figure would stagger off the enormous gaming floor; these men and women had spent the night glued to the brightly lit slot machines, which had swallowed inordinate sums of their money, or so I imagined.

I spotted him immediately. He was as tall as I am, blond but with a slightly receding hairline that exposed a broad forehead. His blue eyes met mine and his face broke into a wide smile. This was Martin, a former jet pilot and one of the top one hundred most eligible bachelors in the States, according to a list compiled by a leading women's magazine ten years ago. Of course he had changed since then, but his increased size had not erased his Nordic good looks, more European than American – to judge from the tapering jaw line and the prominent nose, which was completely different from the miniscule noses of older American families. His great-grandfather had emigrated to America from Germany, leaving the rest of his family on the old continent, including an unmarried sister-in-law, a Miss Gertrude Young, who then spent thirty-five years as the lady companion of the German Baroness Villani. Merely the sound of those European names was sufficient to narrow the gap between the atrium of the Seneca Casino and that part of the world where the art of the Renaissance and its history have a tangible meaning. For this I was almost grateful to the man sitting opposite, who was now telling me his story of the painting, with unfettered enthusiasm. A muffin and a 'bucketful' of Colombian coffee were the best provisions to take on my travels as I sat listening to his tale.

As soon as Martin started to tell me about Miss Young, it became clear that she had acted as the bridge over the Atlantic, the link between the old world and the new. Aunt Gertrude had been born to a modest German family, at a time when the country was brooding painfully over the fact that its grandeur and power went unacknowledged by the rest of Europe. Like many in her situation, she had forfeited sentimental and family attachments in order to dedicate herself to the service of a more fortunate woman, who could assure her a dignified way of life and comfortable board and lodging. The family

and husband that someone of Gertrude's status might otherwise have found would have had too high a cost in terms of hardship and sacrifice; and, even if lived vicariously, the daily life of a noble family was in those days more enticing for many women than the everyday struggle against poverty and prejudice. For thirty-five years Gertrude was the companion of Baroness Villani, and in the later years of her life she befriended an unfortunate young woman, one Johanna von Lilien, who had also been taken under the Baroness's wing. Johanna had tried to live an adventurous life, of the kind that could easily have been appended to one of the fashionable serial stories that women like Gertrude wept over copiously on rainy afternoons, as they looked out on well-tended gardens, through windows hung with Flanders lace. Johanna was very beautiful, and she had fallen in love with an equally handsome and charming man, a few years older than her: Baron Friedrich Augustus von Lichtenberg, honorary Prussian consul in Ragusa, Dalmatia.

Ragusa, now Dubrovnik, was one of those cities that seemed destined to enthral any German who had not had the good fortune or the occasion to visit southern Italy, particularly Sorrento or Ravello. Protected for centuries by its cliffs and high walls, Ragusa lies on the Adriatic at the same height as Naples, but its continental climate means it is much more susceptible to Siberian winds than the Italian peninsula. These cool the torrid Mediterranean summers and make it much more fresh and welcoming, a charming although perhaps less cultured destination for anyone born north of the Danube and the Alps.

The Grand Duke of Austria was captivated by the small island facing Dubrovnik, which became his own private paradise at the same time that Sir Neville Reid, a more modest but no less romantic Scotsman, bought Villa Rufolo at Ravello

and transformed it into another earthly paradise – one that Richard Wagner shared long enough to be inspired to create Klingsor's enchanted garden. The Grand Duke of Austria was less fortunate because, according to local legend, the island was cursed by Benedictine monks, who used to live there and were chased away none too politely. He died shortly after the island had been transformed, but before he had had a chance to enjoy it. Baron von Lichtenberg, the honorary consul, was luckier. During his posting to the Dalmatian city, he met a woman who would change his life by adding her considerable fortune to his enjoyment of this beautiful place.

A flourishing trading republic for centuries, by the mid-nineteenth century Ragusa had become a melancholic outpost on the fringes of Europe, and the influence that had once made it an Italian appendage gradually gave way to the growing predominance of Austria and Germany. Italian had been the official language of the republic for centuries, but it was now only spoken in aristocratic salons and among intellectuals. Instead, on the streets and in barbers' shops, which were the real social meeting places, Croatian gradually became the lingua franca, and by the end of the century it had replaced Italian even in official documents. The city had always been exposed to the risk of attack by Turks or by pirates of any nationality, and this explains its position high above the sea, on a small rocky spur so jagged that it was impossible to land. An artificial channel, enclosing an area barely one kilometre wide and long, also made it impregnable to attacks from the land. Its limited size and dominant position on the route to the east made Ragusa one of the richest, but also one of the most impenetrable cities in ancient times. The senate that had governed the republic for five centuries without a break was made up of no more than fifteen families, whose palaces and accumulated wealth were concentrated within a minuscule

area without any opportunity for display. Moreover, the need for self-defence and the close proximity in which they lived imposed the need for visible democracy. The independence of the republic suffered a fatal blow under Napoleonic occupation, which undermined what was left of the old institutions. From the mid-nineteenth century onwards, Ragusa was gradually transformed into a tourist resort, accessible almost exclusively from the sea. It was visited mainly by the Habsburg and Prussian aristocracies, who replaced the equally decadent Italian nobility as the object of admiration of many Ragusans. The silks and brocades that had embellished the 'visiting rooms' in Ragusa's palaces, customarily open to guests at coffee time every day, were torn off the walls, and the gilt furniture was dispatched to antiques markets through the ports of Venice and Ancona, together with any Greek icons that had found their way to Ragusa, the northernmost outpost of Orthodox tradition and worship. Hoteliers from Vienna turned some of the city's aristocratic palaces into surprisingly modest inns. Century-old traditions crumbled under the effects of the violent changes taking place across Europe. But Ragusa's formidable architecture, which had given the entire city the uniform appearance of a stern but harmonious Italian Renaissance palace, refused to show the signs of decadence apparent elsewhere in cities that had thrived but were now slowly dying. Its compact white stone withstood decay, giving the impression of an unchanging, eternal beauty.

Onto this exotic – but at the same time highly conservative – scene burst the handsome Baron von Lichtenberg, in his military uniform richly trimmed with gold braid, boasting charm and honour more than material substance. He captivated the heart of Countess Nicoletta Gozze, widow of the last heir to one of the leading noble families of the Ragusan republic, Luca Gozze. From the orderly file of papers on the

table, my American host produced a photocopy of a yellowing document inscribed in the copperplate script of nineteenth-century notarial documents: it was the last will and testament of Nicoletta Gozze, *née* Faccenda. The document had an English translation, but I could read it directly in Italian. On 18 August 1847, Nicoletta Gozze, born in Ragusa on 17 September 1811, had married Baron Friedrich Augustus von Lichtenberg, born in Magonza on 14 November 1817. She was 36, and he was six years her junior. Nicoletta's passion had overcome both their difference in age and – more importantly perhaps – their different faiths. The baron was an evangelical Lutheran, while Nicoletta belonged to the Roman Catholic Church, which for centuries had controlled the souls and possessions of the Ragusan nobility; it made them feel closer to Italy, which they thought of as their second homeland and as their closest trading partner. The young couple (although it would have been difficult to describe a 36-year-old woman as young in the mid-nineteenth century) had received a dispensation from the Catholic Church only seventeen days before they married.

In her will, Nicoletta declared her unconditional love for the young baron, 'my most beloved consort Federico de Lichtenberg', but she did not forget her duties to her first husband, Luca Gozze, or to the city's religious institutions. She declared her new husband the legitimate heir 'of all my property, movables, credits, gold, silver and other effects', but only during his own lifetime. On his death, her wealth would pass to the Hospital for Incurables in Ragusa – and this included 'the capital invested, guaranteed or unencumbered by mortgage, and such properties as are in my possession at the time of my death [. . .]'. She then reiterated her confidence in Friedrich's love for her and in the fact that he would take care of her interests during his lifetime. The will was signed

on 11 April 1863, when Nicoletta was a little over fifty and had been happily married for sixteen years. She died a few days later, leaving the handsome Friedrich aged 49, alone and childless. It came as no surprise that, barely two years later, he married Baroness Johanna von Lilien, a beautiful young woman with little else to her name. Their future would be provided for by Nicoletta's wealth. However, Friedrich was aware that his inheritance was only temporary. Ragusa was a small place and the administrators of the hospital had no intention of forfeiting the assets that had been legitimately bequeathed to them.

Having pondered on how to get round the problem, or at least minimise the damage caused by his first wife's charitable compassion, Friedrich realised that he had a more tangible form of *pietà* [compassion] to offer the hospital in exchange: an oil painting on a panel measuring barely sixty-four centimetres by forty-eight, which had hung on the palace walls for as long as anyone could remember. According to family tradition, the painting was by Michelangelo Buonarroti; indeed, a leading local connoisseur, Balduin Bizzarro, another member of the Ragusan aristocracy, had recently recognised it as such on the basis of detailed research carried out twenty years earlier. No one would cast doubts on a family tradition that had always held the connoisseur in the highest esteem. But Ragusa was a long way from Italy, even if it was only a few sea miles from the port of Ancona. The painting had never been seen by the many European collectors who regularly combed the peninsula in search of works of art, or indeed of good imitations of old masters, sold for a song by families whose finances had seen better days. Friedrich must always have thought, privately, that the painting was worth a fortune, but he had never dared to suggest to his wife the possibility of selling it. In the eyes of the Ragusans, the painting encapsulated the

honour and respectability of the Gozze family, who had
claimed it among its prized possessions for centuries. However,
as soon as Nicoletta passed on to a better life, Friedrich did
what any intelligent and cynical man would have done: he sent
the painting to Europe's leading specialist on Michelangelo,
Hermann Grimm, by good fortune a German like himself.
Foremost in his mind was not the honour of the Gozze family,
but rather the fact that the proceeds from the sale of this tiny
treasure would keep him comfortably well off in the future. A
few autograph letters from Professor Grimm were now pro-
duced by my host from his bundle of papers. In 1864 their
author, who very modestly signed himself as 'Prof. Grimm',
was both the greatest expert on Michelangelo and a philolo-
gist of the utmost exactitude. He knew every detail of Vasari's
account and the resulting convictions it had generated in
European art historical tradition. However, Grimm had
recently found an ambiguous and undated letter from Vittoria
Colonna to the artist. It reads:

> To the only maestro Michelangiolo, my most particular
> friend, I have received your letter and seen the Crucifixion,
> which certainly crucified in my memory any other paintings
> I have seen. No other image is better done, more vivid and
> more finished; and, certainly, I could never express how
> subtly and marvellous it is done, because I am resolved that
> it is not by another hand. But you must tell me: if it is by
> another, patience; if it is yours, in any case I will keep it. But
> if by chance it is not yours and you want to have it done by
> that man of yours, we will talk first, because, since I know
> how difficult it is to imitate, I would rather decide that he
> did another thing; but if this is your work, please resign
> yourself to the fact that I will never return it. I have exam-
> ined it carefully using a lamp, and with a [magnifying] glass

and a mirror, and I have never seen such a polished piece of work.

Although the marchesa was describing the *Crucifixion* here, not the *Pietà*, her allusion to 'any other paintings I have seen' and her painstaking examination by using 'a glass' and a 'mirror', in which the most minute details of the image were reflected, sowed a seed of doubt that was sufficient to convince Grimm that there might be other paintings by the master.

A few months after examining the painting that had been sent to Berlin, Grimm published his monumental *Life of Michelangelo*, in which he mentions seeing a *Pietà* from Ragusa that had impressed him sufficiently to prompt him to hypothesise Michelangelo's direct intervention. However, the counterclaims introduced by Vasari's account were still too considerable to be ignored. The painting was not sufficiently well received in Berlin and was returned to Ragusa. But, in a turn of events that seems to have been lifted straight from some theatrical melodrama, barely one year after the painting had left Berlin, Marchese Giuseppe Campori, a renowned art historian and careful archivist, published a letter in Italy that clarified, once and for all, that Michelangelo had painted a *Pietà* for Vittoria as well as a drawing. Grimm was now fully convinced that the small painting in Ragusa was Michelangelo's own work. The man opposite me now handed me a short article that Grimm had written in 1868 in German, together with an English translation.

Johanna von Lichtenberg, who was widowed on 3 October 1877 after having been married for fifteen years, was similarly convinced of its authenticity. Following the letter of the will, the Hospital of the Incurables immediately laid claim to her husband's property, and Johanna was left in serious financial

difficulty. She sold what she could, so as to pay for her journey home, but kept the small *Pietà* for herself. Back in Germany, she was welcomed in Frankfurt by Baroness Villani, a childhood friend of her mother's, in whose house Miss Gertrude Young still lived as a lady companion. The young widow suffered from a serious eye disorder, and Baroness Villani cared for her generously. In the meantime the former resumed correspondence with Grimm, in the hope that he would help her to sell the painting to a German museum. Baroness Villani then took up this cause on behalf of her friend's daughter and found another convinced supporter in the painter Edward Jakob von Steinle. In a heartfelt letter to Grimm, Steinle wrote:

> In 1832 I spent a whole month studying Michelangelo's work in the Sistine Chapel, and this painting brought back the impressions I formed during that time – in every way, and so vividly that I would find it more difficult to say that it is not by Michelangelo than I would to say that it is his.

Steinle was one of the greatest German artists of his time and a considerable expert on Italian Renaissance art. He made a stab at valuing the painting at a minimum of 12,000 dollars and beseeched Grimm to convince the German museums not to let a work of such importance elude them, since it would be an unforgivable loss for Germany. Grimm answered both the baroness and Steinle with a polite letter, written from the Grand Hotel in Vienna, dated 30 September 1883 and addressed to the baroness. This, too, was in the file of papers my contact laid before me:

> Most Gracious Lady, it is very difficult to add anything to what I wrote in my book. In Berlin I was in a minority when

the question of buying the painting was raised. There is no proof that such a work by Michelangelo could ever have existed, although the possibility cannot be excluded that one of the artists working under his supervision, Marcello Venusti perhaps, may have painted it in Michelangelo's name. On the other hand, I can only repeat that, when I saw the work, I had the most vivid impression that Michelangelo himself may have been actively involved in its production. To say any more would be to go beyond the natural boundaries that constrain anyone who has been asked to formulate a judgement in cases like this. With my greatest respect and devotion. Yours faithfully, Prof. Grimm.

This was a dead end, and all the while the need for a sale became more imperative. It was at this point that the idea of sending the painting to America was suggested, as you would send an emigrant who had fallen on hard times at home and might seek his fortune in the new promised land, where talent of all kinds was welcomed with open arms. Miss Young's brother-in-law, Mr Martin Neejer – the great-grandfather of Martin who was sitting opposite me – had made his fortune in America. The painting was sent to him, crossing the Atlantic with a boatload of hopeful emigrants obliged to seek in America the recognition they were denied on the old continent. The painting from Ragusa took its place among supplies of home-made food intended to relieve the rigours of the crossing, best clothes packed in suitcases tied with string, and hearts saddened by farewells.

5

ISABEL ARCHER

Isabel Archer is the most fitting guide to that New York where the painting arrived in 1885 and where it was exhibited at the recently opened Metropolitan Museum, standing as it did on the edge of Central Park with its neo-Gothic outline, designed by Vaux Calvert and Jacob Wrey Mould. Indeed, it was said that Henry James's lissom heroine would be 'capable of marrying Mr Osmond for the beauty of his opinions or for his autograph of Michael Angelo'. Isabel perfectly sums up the feelings of fascination and conflict between this tumultuous American city, busy building its own myth of wealth and entrepreneurship, and old Europe. The latter was an ambiguous and decadent world, yet it still epitomised beauty and elegance, both of which were sorely missed across the Atlantic: there even the richest houses were wedged between streets filled with clattering trams and bustling crowds. Isabel confided that

[h]er life should always be in harmony with the most pleasing impression she should produce; she would be what she appeared, and she would appear what she was. Sometimes she went so far as to wish that she might find herself some day in a difficult position, so that she should have the pleasure of being as heroic as the occasion demanded. (Henry James, *The Portrait of a Lady*, Penguin Classics, 2003, p. 105)

Hers was a vocation for frankness, simplicity and the strength of the American spirit in contrast with the ambiguity and corruption of European society to which, like other members of the American elite, the girl was fatally attracted.

In the hustle and bustle of fin-de-siècle New York, a city in constant flux, wealth created an opportunity for luxury that saw the old European rituals as a timeless vogue. Italy was perceived as a place of calm, unchanging beauty, a place that evoked a paradise for which there was no space in this noisy new world. Overwhelmed by such riotous development and fascinated by a city where you could take a tram to the docks, board a steamship and be under way within a few hours, New Yorkers were coming to Italy to gaze in astonishment at its unchanging, peaceful landscape, so perfectly manicured by its inhabitants over the centuries that a more beautiful scene could not be imagined, not even by those with the most fervid imaginations.

For a brief period Italy became the ultimate destination for elegance and beauty for northern Europeans and, above all, for Americans: indeed, while the former had for centuries maintained the remnants of trading relations and an admiration for the oldest and most southern part of the continent, for the latter the novelty added a touch of the exotic to Italian landscapes. It was hardly surprising, then, that Americans wanted to take home a memento of that myth which

Renaissance art had carried to the height of sophistication, or that the first truly wealthy families of New York hastened to buy and collect Italian works of art. Moreover, the houses and palaces built for these collections appeared to have been transported – with the nonchalant wave of a magic wand – from Florence, Rome and Venice to the 53rd Street. Except here they were built in red brick, whose bluntness was only marginally softened by the new industrial paints. But that nonchalant magic wand was unable to conjure up the clear skies of Italy above the great avenues, or the slender trees that captivate the spirit in the altarpieces of Raphael, Perugino and Ghirlandaio. This could only be achieved inside the private mansions, where closely guarded paintings set the outline of the Umbrian hills against the city's aggressive skyline and brought the transparency of Italy's rivers and lakes to the banks of the cold, muddy Hudson. The Americans' desire for tranquillity and beauty, together with their need for truth and simplicity – values that underpinned the new American way of life from the outset – steered the taste towards that phase of the Italian Renaissance that had resolved every conflict, assuaged all anxiety and reawakened dreams of a new golden age, blind to the wars and tragedies devastating the peninsula.

It was the English who had already paved the way, with the vogue for the pre-Raphaelites: from the vast panorama of the Renaissance, they selected those artists before Raphael whose works – painted in brilliant colours and devoid of all anguish – portrayed faces suspended in perennial contemplative ecstasy. Such sentiments curbed the anxieties generated by the Industrial Revolution in England and amplified on the other side of the Atlantic. The English art critics interpreted the Italian artists who followed Raphael's mature phase as heralding a state of anxiety they did not wish to, or could not, confront. It was an interpretation that chimed with America's

rich collectors. Indeed the largest collection in New York, which was begun by J. P. Morgan, focused almost exclusively on late fifteenth-century art and on those painters and sculptors who could soothe anxieties without creating others. In 1880 this wealthy banker built a house at 219 Madison Avenue to accommodate his artistic treasures, mainly from Italy, and in doing so he undoubtedly set the standard for the city's taste during the following years. In his prodigious library he surrounded himself with works by Bellini, Perugino, Lippi and other late Quattrocento artists. Moreover, it was impossible for nascent American capitalism, based as it was on loyalty and on an inviolable set of rules – in which it sought and found a harmony that seemed so natural it became a religion – not to see itself reflected in paintings emanating from a rule so perfect that it coincided with a harmonious law of nature.

But this was not the case of the *Pietà* from Ragusa, which proved instead an enormous disappointment. Generally speaking, Michelangelo was not popular among nineteenth-century collectors because he was the complete opposite of the calm clarity from which he, too, had emerged. Moreover, in this particular work, Michelangelo seemed deliberately to undermine and confound the myth of Italy and of the Italian Renaissance as a mirror of harmony and of the golden age. The small painting resembled nothing the Americans had seen before. The landscape had been violently excluded from the *Pietà*, and the entire scene was devoted to the internal drama of Christ's death and to the contemplation of the Madonna's pain. As the fading daylight gives way to night, a cataclysm is announced. The clear southern skies have vanished, as have the silhouetted tree-tops and the picturesque villages glimpsed in the sunset, lying between rocks and streams. There is only a rock–altar–tomb, on which Christ's body lies in an extreme evocation of the communion rite.

Gone, too, is the graceful figure of Mary. The figure whom Michelangelo had portrayed in his youth as an immaculate virgin is now a mature woman, racked by a pain so profound that it can barely be repressed in her silent cry. Her physical presence and the immediacy of her situation go straight to the heart; there is no beauty, no natural grace to offer consolation or lingering pleasure. As he had done in the *Last Judgement* and in the frescos of the Pauline Chapel, here Michelangelo portrays men and women whose faces are etched by passion and grief. Grace has withdrawn from the world, condensed into the violent light that reveals the presence of the living faith. In the painting that New Yorkers admired during the summer of 1885 there is an unnatural, dramatic light that only Caravaggio, another little-known artist who was also not in vogue at the time, had re-evoked in his works. Above all, what Michelangelo's *Pietà* lacked was context: there was no body of work in which to position the painting, no before or after. Its daring composition had deterred any would-be imitators; but, more importantly, the Madonna was so violent that she represented a complete break, a caesura, not only with Renaissance and High Renaissance canons, but also with the canons of western painting and with western Christian tradition as a whole.

Isabel Archer was accustomed to spending months at a time in Italy, travelling between Rome and Florence and visiting the major public collections. She had seen the illuminated church altars and the paintings that provided a frame of reference for lively conversation in the private houses where she stayed. Yet even a sophisticated New Yorker like Isabel was struck dumb by that small panel. Michelangelo had not painted it for women like her. He had not even painted it for the fashionable circles of his own day. Michelangelo had painted it for himself and his friend Vittoria, since they had

both refined suffering into such profound devotion that it enabled them to understand the full significance of that revolution.

Moving forward fifty or so years from the panel's arrival in New York, not even the specialists of the twentieth century would understand this extreme phase of the master's art; indeed they even saw his greatest masterpiece, the Pauline Chapel, which stemmed from the same sentiment of exasperated creativity and devotion, as the tired, outmoded work of an ageing and worn-out genius. It was an interpretation that completely disregarded the fact that old age and exhaustion did not prevent Michelangelo from working for a further twenty years, creating works of such extreme perfection as the Bandini *Pietà*, the Rondanini *Pietà* and St Peter's itself.

6

THE MEETING

I could not share these thoughts with the man sitting opposite me, primarily because my English was not good enough, but also because they came to me piecemeal, in flashes. Martin still found it hard to believe how little attention the painting had attracted when it was exhibited at the Metropolitan; and it did not fare any better a few years later, when the *Pietà* was included in an exhibition at the Syracuse Museum of Modern Art. After that the painting slowly vanished, smothered by the devotion of the Neejer family.

Baroness Villani had purchased the painting from the unfortunate widow of Baron von Lichtenberg, and in her will she then bequeathed it to her lady companion, in gratitude for thirty-five years of service. In 1905 Miss Young, in turn, left it to her brother-in-law; and the man sitting opposite me had inherited it directly from him. There was nothing more to tell about the modern history of the painting, which had been ignored even by Charles de Tolnay in his catalogue of the

copies of Michelangelo's works. De Tolnay thought it had remained in Ragusa, where Grimm had left it; instead it was here, in America, only a few kilometres away, like one of those emigrants who wait patiently in a sleepy North American suburb for their moment of glory to come.

By now it was full daylight, and the University of Buffalo laboratory, where I had arranged for tests on the painting to be carried out, would be open. We made our way to the university across an industrial landscape hard hit by the crisis. The automotive industry had turned Buffalo into one of America's most thriving cities, but the area was now struggling for a new role, and even for its own survival. Low façades in brick lined the streets, brightly coloured but deserted. Each block was plastered with such huge and elaborate logos that the entire urban setting seemed to have been designed as a backdrop for them.

It has become a rather overused simile to compare the table of an art restoration laboratory to an operating theatre. But, unlike the human body, which is belittled in the operating theatre, deprived as it is of the aura that makes it fascinating and desirable, a painting exercises its greatest attraction precisely under these circumstances. Perhaps this is because we are accustomed to approaching in the utmost intimacy the body of the person we love, whereas from a painting we are always kept at a distance, separated by other visitors, by glass, by museum attendants, by its own fame – as the millions of visitors who try to get closer to Leonardo's *Mona Lisa* at the Louvre every year know too well. During restoration, the painting ceases to be an image and it, too, becomes a body: a body with a tactile feel, a history, even a smell. Who would ever think of associating an image with a smell? The restoration laboratory reveals a painting's secrets, its strengths and weaknesses, depending on its nature. The loss of public aura

is amply compensated for by a sense of intimacy denied to others, which is all the more exciting as it makes the restorer into a privileged individual, someone with an exclusive relationship with the work.

The painting was laid on a large table covered with tissue paper. Although I knew its dimensions by heart (sixty-four by forty-eight centimetres, not much larger than the cover of an expensive coffee-table book), I could not help but be surprised by its smallness. From the photo I had clearly formed the idea of a large altarpiece, such was the solemnity of the figures. As I drew close to the table, grasping the hands of the kind laboratory director and of an Italo-American student who had been summoned as my interpreter, my eyes darted over the panel on the table and I tried hard to conceal a sense of disappointment.

The room was silent, so different from what you would find in an Italian laboratory. This silence added a solemnity to the event, as did the fact that, to an Italian, American technology always seems wholly unattainable in its perfection. The heavy cream doors closed noiselessly. The neoclassical architecture was designed to give the building a decorum that did not interfere with its functionality and made its spaces and corridors pleasantly welcoming. It was the complete opposite to the laboratories at the Istituto del Restauro in Rome, where I trained. There the facilities were crammed into the maze of narrow passages and enormous halls inside the old Borgia palace at San Pietro in Vincoli, creating practical difficulties of every kind. The six-metre-high organ shutters painted by Il Pordenone [Giovanni Antonio de' Sacchis] could not be brought inside because no door was big enough, and a painting by Antonello da Messina had to be hung in one of the formal salons where voices bounced off the walls. To make up for these shortcomings, the inlaid wooden ceilings and the

painted walls gave the impression that the works had always been there and were perfectly at home in their surroundings. The fittings in the laboratories at Buffalo consisted of a few high-definition screens, which were already displaying the results of the infrared reflectography – an imaging technique that penetrates the colour and reveals what lies beneath, namely the underdrawing from which the artist started.

I approached the screen first, knowing I would learn more from science than from my own eyes; at least, that's what I had willed myself into believing at the time, caving into the American myth of the primacy of technology. Indeed, the painting on the screen was much more beautiful than the one visible to the naked eye. I was enormously relieved to see that the paint was still intact under the black hole which obliterated the Madonna's teeth. There was no lacuna, only the remnants of grime. Without this stain, the face of the Madonna acquired astonishing strength and beauty. I then enlarged Christ's head and an obvious *pentimento* appeared – a change made by the artist during the process of painting: to start with, the artist had drawn the head with marked foreshortening (the right cheekbone disappeared behind the tip of the nose), but then he had changed his mind, radically altering and broadening the right profile until the whole cheek and chin could be seen. The nose was lengthened and the eyes lowered; the parting of the hair at the brow had been moved, so as to follow the new central axis of the face. Some areas of the face were rather opaque, suggesting a later repainting. Another of these more opaque areas was the Madonna's left eyebrow, which seemed stiff and thin compared to the right-hand one. The latter had been painted with a few soft brushstrokes that created a perfectly curved eyebrow, one of the high points of the painting, worthy of a great masterpiece. Yet, contrary to my own silent deductions, the director of the laboratory then proceeded to

tell me that the tests had shown no signs of earlier interventions or repainting. It was a view supported by the owner himself. Indeed, I remembered that Martin had told all those who had been shown the painting that it had never been touched, and even Grimm had said as much.

On the grounds of what I had just seen, this was an insuperable problem. Mary's right eyebrow and Christ's face clearly showed a loss of quality that could only be explained by restoration. No artist capable of achieving the sublime heights that could be glimpsed in the painting – in the Madonna's bust, for example, in the heads, in the body of the angel to the left of Christ, and in Christ's torso – would have included that clumsy emphasis, those simplifications that violently hindered an appreciation of Mary's and Christ's faces.

I asked the kind student who had been unexpectedly landed with the job of interpreting for me – which she did with a great deal of commonsense – to translate the laboratory director's report not once, but twice. I also sensed her unease at the arrival of this Italian art restorer, a figure of somewhat dodgy professional correctness, whose diagnostic approach would, as a result, almost inevitably lack rigour. For my part, I promised myself not to launch into those long-winded diatribes that often got me into trouble. So I kept quiet and gazed at the screens, which told a different story from the authoritative version outlined by the director. The young student, whose sensibilities were still very Italian, was aware of my embarrassment, but I also felt she was on my side, offering me moral support in that cold room in Buffalo University. Moreover, as he had used his instruments – which, it has to be said, seemed to be of excellent quality – I could not challenge the director's authority on his home ground. During all of this, the painting's owner was standing slightly apart and trying to work out what was going on between these two silent rivals.

I decided to take a closer look at the painting, to do what I was best at, and indeed what I should perhaps have done as soon as I entered the room. There were white lights shining brightly down from the ceiling, but these were no good to me. However, the room next door, which contained a few easels holding paintings to be retouched, had two tall, shutterless windows, which let in the milky northern light found above the forty-sixth parallel. Most of the paintings were late nineteenth-century portraits of American women at which I glanced with as much hypocritical interest as I could muster. I asked if I could momentarily move the stout lady with a buttery complexion, who sported a millinery confection of yellow petals, and in her place I stood the Ragusa panel. I only needed to move the easel to a spot where an incidental ray of light fell on the painting, to realise that there were two conspicuous alterations to Christ's head.

The painting had been restored, and the evidence of these alterations alone was enough to refute the laboratory report. It was a situation in which my stilted English proved immensely helpful. In the lengthy process of conveying the message from me to Louise, and Louise to the laboratory director, there was time to soften the rather conceited tone I had instinctively adopted. The director wanted to see the changes before he would admit to having been wrong, but finally he did so. We carried the painting back into the other room, turned off the lights and instead shone a Wood's lamp at the panel. This is an ultraviolet light that produces an opacity at the place where colours have been applied over the original painting. The lamp confirmed what I already knew I had seen. What was more, the results persuaded the director to agree with me; Louise and the owner looked on, in the meantime, without talking. I went back to the window, holding the painting in my hand, like precious booty.

I had taken the first step. Certainly, it was information I would have preferred not to have discovered, but I was now convinced that the main weakness of the painting had been resolved. I could look at it now without a qualm. No photograph, no digital copy can reproduce the real essence of a painting; no replica can be more lifelike than the real thing, despite the claim made in the curators' bulletin of the Louvre after displaying a technologically generated copy of a work by Paolo Veronese. It is completely untrue. Painting has a relief that no reproduction can recreate: the palpable quality of the brushwork, the denseness of the dark browns and the transparency of the lac, the way the ground can be glimpsed through the layers of paint and the curving sweep of dark brushstrokes across the sky. All this gives a physicality to the image that no copy can ever replicate, although it has to be said that this is understood by a small and ever dwindling number of people, in view of the hurried enjoyment of art today.

Seen in clear spring-morning daylight, the painting surrendered, exposing all its secrets. The colours were smothered by yellowed coats of varnish that flattened the reliefs, carefully constructed by using light and shadow. The forms and the expression of the Madonna's face, so moving when seen close-up, were disfigured by those dark stains in her mouth. It looked as if some teeth were missing. The dirt under the opaque varnish flattened the sense of internal space and made its tonalities uniform, giving everything a yellowish brown colour. Mary's mantle looked green against the underlying blue, and the coloured shadows could barely be guessed at from under the dark brown layer. The direct light highlighted dense clots in the dark areas of her mantle which were thicker and more prominent, as if they contained solid pitch. The painting looked like many other relatively untouched

antique paintings, created by using such excellent technique that the colours acquire physical consistency. Although the yellowing varnish blurred the colours and the shapes, beneath it the force of Michelangelo's painting transpired intact. The face of the Madonna was so plastic that it seemed sculpted in colour. The paint was solid but even; the sharp outlines were drawn in the Florentine tradition, but the colours were as thick and soft as in the Netherlandish school, a stylistic pointer common to just two painters: Michelangelo and Bronzino. But the latter would never have achieved the breadth of chromatic background that was apparent in these bodies. The painting had that indefinable quality, that presence, as art restorers say when describing a work that surpasses stylistic mediocrity. The sense of space between the figures was so tangible that Mary's lifted arms seemed able to accommodate and comfort other angels or martyred sons. I gazed at the painting in complete silence, so as to leave with its image clearly impressed in my mind.

By then I was convinced of the painting's authenticity. I thought of the words I had read in Grimm's letter a few hours earlier, in the atrium of Seneca Casino: 'when I saw the work I had the most vivid impression'. There was not much that I could add to his comment, even if Grimm had perhaps been lucky enough to see it before it was restored and before the varnish had darkened.

It was liberating to think of Grimm's excitement – Grimm, who had believed in the painting even before new documents emerged to clear away the prejudice; and to think of Von Steinle's enthusiasm for the small panel – Von Steinle who, after spending a month copying the figures of the *Last Judgement*, had come to think, as I had, that he was back in the Sistine Chapel. The presence of the painting had already performed its first miracle by recalling that thought. From the

outset, when I started to imagine the possible developments of the story, the idea of the academic world's resistance to a proposed attribution of this kind had disheartened me. A *Pietà* by Michelangelo with a history like this could even surpass the *Mona Lisa*; but in the former case the process of attribution was unique in that it could not rely on stylistic comparison, since we know of no other movable panel paintings by Michelangelo, except for the Doni *Tondo* [= the round-frame (*tondo*) painting *The Holy Family with Saint John*, made on wood, in 1506, at the request of Angelo Doni].

Michelangelo did not paint panels, let alone small-sized panels. The philological prejudice that had led experts to ignore documents first published two centuries ago would have prompted the international community of art historians to band together in order to reject the proposal – all the more so as it raised an undeniable charge against the self-referentiality of their discipline. Lastly, the number of recognised academic authorities on Michelangelo can be counted on one hand. Martin had told at least half of them about the painting, but they had ruled it out on the grounds that it simply could not exist, and therefore had to be a copy. Given the background to this whole affair, it would be impossible to have a serene and reasonable debate. But what really discouraged me was the idea of having to join in an airy discussion about the painting's form, or about the beauty of its style and pictorial quality: clever rhetoric could exalt and twist such elusive categories, or burst them like iridescent soap bubbles. The prospect of having to sustain such rhetoric was extraordinarily disheartening.

But now, sitting in front of this minute but impressive panel, I was struck by this liberating thought: I would not have to join in that debate because Hermann Grimm and Edward Jakob von Steinle had already done so a century

earlier. Their arguments would undoubtedly seem wholly plausible even to the most diffident contemporary academics, because these men had lived in a world where a knowledge of art was not yet mediated and corrupted by the use of art photography. I was so relieved that this job had already been done. I would not have to discuss the quality of the painting with anyone; certainly with none of the experts whom I knew so well, and who, as I had seen from my eyrie up in the restoration scaffolding, were capable of all kinds of intellectual skulduggery.

My task would be quite different: I had to deepen my knowledge of the painting in front of me and mine the tangible qualities of the material object, because that was the path I knew best how to follow. For the second time that day, I found myself grasping a hot beakerful of American coffee and fighting off the drowsiness caused by jet lag.

Since my arrival that morning, I had wanted to walk into one of the coffee shops around the university campus, because I imagined it would like entering a Winslow Homer painting. The same basic yet grandiose forms, the same dark red bricks on the walls; exactly the same green-painted windows, the yellow signs that shone like gold. But, above all, it was the shadowy, mysterious windows of the buildings in Buffalo, awaiting the arrival of the crowds, that evoked the disturbing works of that American painter – the one who had known how best to express the bewilderment that underlay the endless stream of wellbeing and familiarity. Walking into one of those paintings, now that my mind was so full of Michelangelo, might give me the lucidity and calm I needed in order to tackle the second stage of the examination. My interpreter, Louise, came with me and I was grateful for her intellectual loyalty. She had not taken advantage of the fact that the other two did not speak or understand Italian to shed any of her

composure, under which it was quite clear that she was mulling over thoughts that would not quite come to the surface. Certainly not then, at least.

Once we were back in the room, I started to examine the back of the panel. It was made from a single plank of fir, a wood that was unusual for central Italian paintings but extraordinary in this particular instance. Normally two planks would have been placed side by side to obtain a width of 48 cm, as in the case of Venusti's copy at Galleria Borghese in Rome. But, as every artist knew, the two segments could separate slightly over time, as the individual boards warped. Here this problem had been solved, once and for all, by the good fortune of finding a single board of the right dimensions. Poplar was the wood most commonly used in central Italy as support for panel paintings, because it has fewer knots around which the wood can rot more easily. But the fir panel I held in my hands had been cleverly modified through a technique used by a few of the greatest Italian artists, like Francesco Salviati. Two knots had been extracted and replaced with rounds of wood that slotted perfectly into the panel. The result was excellent, because the wood showed no deformity whatsoever. Even the thickness had been reduced to a few millimetres by using a clever procedure. The movement of wood is proportional to its thickness: by reducing the latter, there is less risk of the former.

As I noticed these highly original modifications that had turned the panel into an excellent support, I could only marvel at how perfectly they had succeeded, enabling the painting to survive well beyond the expectations of the man who had made it. A painting that had travelled from Rome to London, from London to Ragusa, from Ragusa to Berlin, from Berlin to Ragusa, and again from Ragusa to Frankfurt, not to mention crossing the Atlantic Ocean at a time when the

clima-box had not even been imagined, would certainly have suffered terribly if it had not been a technological masterpiece.

Behind me, the painting's owner and Louise watched with trepidation as my hands brushed lightly over the panel, touching and testing the wooden support. As I engaged in this silent 'conversation' with the panel, a doubt crossed my mind. In order not to deprive kind, shy Louise of her role as interpreter, or perhaps, more cynically, so that my halting English would not rob me of the respect with which the others now treated me, I asked her to ask Martin where the painting had been kept in recent years. I understood his response even before it had been translated. Or more precisely I understood the affection with which Martin launched into a description that, for any art restorer, had the makings of a real horror story. 'The painting always hung in my parent's living-room. As children we used to call it "the Mike", because we were so fond of it. It was only moved after it was hit by a tennis ball during a rather boisterous game and fell off the wall.'

It was not the fall that shocked me, but the idea that the painting had been subject, year in year out for decades, to the central-heating vagaries of a middle-class family home. I looked down at the panel disconsolately, but its condition would have been the envy of almost any painting housed in a leading museum – one fitted with meticulous hygrometers for the purpose of warding off the slightest change in temperature. If the painted side of the panel showed the artist's genius, the back revealed the genius of an engineer whose experience was quite clearly out of the ordinary, outstripping that of any normal craftsman. I had been astonished to learn that the wood was not poplar, which was commonly used in central Italian workshops. Now, I understood the reasons for this choice. Anyway, why would Michelangelo have had poplar in his house in 1545? He was not a workshop painter, and even

his choice of technology set him apart: each masterpiece was created using original, perfect techniques, which were far superior to those developed by artists whose craft should have given them greater technical expertise.

When I started work on the restoration of Julius II's tomb in San Pietro in Vincoli, Rome, even I found it hard to believe Michelangelo's extraordinary engineering skills. The artist had opened a large lunette in the transept wall above the tomb, to allow light in from the back. However, by doing so, he created a risk that the vault supported by the partially demolished wall might collapse. To prevent this, an iron chain had been set into the weakened wall, tying it to the solid wall opposite, so that the latter would absorb the thrust of the entire vault. For years, this very modern solution had been wrongly regarded as the result of a twentieth-century restoration, before an analysis of the plaster and of the loose coloured paint proved without doubt that Michelangelo had designed the chain, to counter the risks of building. In the same way, here, too, he had combined the choice of an unusual wood with the technique of replacing the knots. In the case of San Pietro in Vincoli, his engineering genius had prompted the idea of opening a lunette whose illumination served to backlight the statues – anticipating the Baroque; and in the second case here he had used a single board instead of two, thereby improving the chances of the painting's survival over the centuries.

Faced with Michelangelo's technical creativity, it is impossible not to compare it with the exalted results he achieved. However, we should resist the strong temptation to link his constant search to improve the life of objects to the critic's need to establish overly mechanical links between the myth of Michelangelo's genius and his working procedures. Essentially, Michelangelo was able to put into practice the experience he

had acquired during the time he spent in some of Italy's most technologically advanced workshops. In this particular instance, he may have remembered Domenico Ghirlandaio's workshop, a hub of the world's most advanced technological knowledge, where he had worked until 1487 or later.

This attitude was related to a straightforward form of logic, which, when the time was right, allowed him to achieve leaps of knowledge that are difficult for later generations to understand precisely because of their extreme simplicity. I had also had occasion to witness this logic when I first started out as a researcher: after reading Vasari's description and comparing it to the testimony of the holes found during restoration work on the Sistine ceiling, I had discovered that Michelangelo built his innovative scaffolding to paint the ceiling simply by using and improving the traditional Tuscan *sorgozzoni* – cantilevered wooden rafters that had been used for centuries in Florence to support the projecting parts of buildings. He had simply modified this tradition by placing two *sorgozzoni* opposite each other, to narrow the distance to be covered by the supporting beams of the scaffold.

The addition of the word 'simply' – the inevitable conclusion to any scrutiny of Michelangelo's works – ends up by distracting experts, who look for Michelangelo's genius in complexity rather than in a highly sophisticated use of simplicity, therefore making many of these procedures incomprehensible. It was the myth of Michelangelo that prompted the academics whom the Vatican Museums involved in the restoration of the Sistine ceiling to hypothesise the invention of amazing engineering structures, thereby diverting attention from the solution suggested by common sense.

Here too, when dealing with the small fir panel, Michelangelo had done precisely what carpenters do to improve the resistance of any piece of wood weakened by

knots: he had extracted them and replaced them with an inert plug. The support that I held in my hands proved that, in spite of its simplicity, this had been the best possible solution. However, my willingness to use common sense and a detailed knowledge of artistic practice to fathom Michelangelo's creative procedures was of no avail when it came to solving the one question that could throw considerable light on the painting's history: the identity of the wax seals on the back of the painted panel.

7

THE WAX SEALS

The two wax seals on the Ragusa painting were illegible at first sight, as other experts who had inspected the painting before me had already commented. It is not very common to find wax seals on the back of sixteenth-century paintings. They are a sign of ownership and were usually added at a later stage in the life of the work, when an inventory was compiled or when a painting changed hands. The procedure, which was used first and foremost in sealing letters as a way of certifying their authenticity, consisted of melting a stick of sealing wax over a flame, so that it dripped onto the support. An emblem, generally the owner's or the writer's coat of arms, was then pressed into the hot wax.

Wealthier owners tended to use a hollow die for their seal, so that, once withdrawn from the setting wax, it left a clearly visible design in relief. The secretaries of princes or other individuals who corresponded frequently used special lead stamps, or even *intaglio* gemstones for this purpose. The

complexity of the seals used for correspondence from princely courts or from the Vatican secretariat was sufficient proof of authenticity because the die, often protected in a special lead *bulla* or capsule, was impossible to imitate. Alternatively, a relief seal was easier and therefore cheaper to make; but it left a hollow and less clearly legible imprint. These seals, in particular, were often made using rings whose gemstones were carved with a 'cameo' or raised relief.

The seals on the panel were of the latter type. They were difficult to decipher not only because the relief was poor, but also because they had been made in haste on a layer of sealing wax only a few millimetres thick. The situation had not been improved by the corrosive substances used at some later stage to clean the back of the panel. Martin and his relatives had tried to identify these seals for years, in the vain hope of deciphering the proud column that marked the arms used by the Marchesa Colonna or the winged talon used by Ludovico Beccadelli – a *letterato* from Bologna and a close friend of both Pole and Michelangelo, who was Archbishop of Ragusa between 1555 and 1560. Modern academics have legitimately focused on the latter figure in their search for a link between Michelangelo, Vittoria, and far-off Ragusa, where the painting was mentioned for the first time in 1840; and I have to say that I, too, thought that Ludovico Beccadelli played some part in the painting's history. The learned prelate from Bologna had been in Pole's service during the Council of Trent, and during the last years of his life he had also been a friend and admirer of Michelangelo. This is proved by two letters they exchanged, dated 1557 and 1558, – complete with sonnets, since both were amateur poets.

Beccadelli was appointed Archbishop of Ragusa by Paul IV, the great inquisitor who persecuted Pole and Morone, the key surviving members of the *spirituali* (Vittoria had been dead for

almost ten years). Indeed, Beccadelli's nomination, as he repeatedly lamented in his private letters, amounted in practice to an exile, a veiled condemnation for having belonged to Pole's 'heretical family'. The fact that Beccadelli shared the group's special devotion, which had attracted the attention of the Inquisition immediately after the publication of *Il beneficio di Cristo*, is confirmed not only by his relations with various other members who were scattered by Paul IV's bitter attack, but also by an explicit letter he wrote to Cardinal Santacroce on 23 January 1544. The two were discussing the barely veiled heretical content and inquisitorial persecution of the short treatise. In the abridged version prepared by members of the *spirituali* group, the *Beneficio* exalted a faith very close to Lutheran theology, and its influence was such that the whole history of Italy in mid-sixteenth century appears to have revolved around it. Beccadelli wrote:

And I still try to do all the good I can, in the knowledge that trees that bear no fruit are useless and should be uprooted. Yet I do not rely at all on any work I undertake, but instead, as Your Most Reverend Lordship will well remember, saying *servus inutilis sum*, I take refuge in Jesus Christ, who alone has opened the way to paradise to us. For this reason I liked the booklet mentioned above, which I saw three years ago, since it seemed to me that it took this approach by telling us about the benefit of Jesus Christ and kindling our passion for Him, as is proper. I was also convinced by the authority of the person who abridged it, whom I hold as a learned and good man. Now, whether there may be ambiguous and scandalous things scattered through it, either out of ignorance or out of malice, I do not intend to give them my consent at any event. Instead, sharing the judgement of Your Most Reverend Lordship and other learned and good

persons, I intend (wish) to live and die a true son of the Holy
Church.

By his own admission, Beccadelli's faith followed the teaching
of Pole and Vittoria and came dangerously close to Luther's
convictions on account of the scarce importance attributed to
'works'. Instead his hope of salvation relied on Christ's sacri-
fice, as set out in the booklet abridged by Marcantonio
Flaminio and Pole, who are prudently not referred to by name
in the letter. It is precisely these letters from Ludovico
Beccadelli, many of which are unpublished and, above all,
unknown to art historians, that reveal how intimately
Michelangelo was involved in the group, to an extent that
far exceeded Vittoria's mediation. Beccadelli wrote to
Michelangelo on 28 March 1557 and on 6 April 1558. He
spoke about him to another group member, Giovanni Abbati
(a figure not yet identified in the historiography on
Michelangelo), in his letters of 2 January 1556 and 12 March
1556. In another letter, also dated 1556, he mentioned
Michelangelo to Alvise Priuli, Pole's secretary and possible
lover, who had moved to London with him. Lastly, writing to
Filippo Gherio, who had been Morone's secretary and a
member of the group for many years, he described the villa he
built on the small island of Šipan, facing Ragusa, where, in
order to ease his nostalgia for his distant friends, he decorated
the walls with frescoed portraits of many friends from the
group, 'among whom our Michelangelo is very alive and looks
like he could almost start a debate. This gives me much
consolation.'

There were few other men with whom Michelangelo
enjoyed such intimacy in the last years of his life. On the other
hand, precisely this close relationship and Ludovico
Beccadelli's refined taste and learning – he was an avid art col-

lector as well as a patron – make it difficult to explain why the bishop left the painting in Ragusa when he returned to Italy.

Money is always a good reason, in Europe as in America; and Martin would have loved to identify at least one of the seals as Beccadelli's coat of arms. This would have neatly filled the lacuna of three hundred years between the letter confirming the presence of the painting in Trent in 1546 and its first modern sighting in 1840. Martin had tried to photograph the seals under every possible type of light and then manipulated the results by using a computer, but to no avail. Technology always disappoints precisely at the point where we expect it to produce miracles.

For at least half an hour I examined the seals from every angle, using a series of different lamps. Martin, Louise and the now rather offhand director of the department must have thought I was extraordinarily focused as I went about my business in the aseptic laboratory at Buffalo University: they scrutinised me while I scrutinised the painting. However, if I came across as a scholar with admirable powers of concentration, that was a mistaken impression, because in actual fact I was trying to ward off a seductive but totally irrational thought, which, like points on a railway, threatened to send my disciplined approach off at a tangent. For a period of his life Ludovico Beccadelli had also been the Bishop of Ravello, the splendid city on the Amalfi coast, only a few kilometres from the village where I was born.

For four years, between 1994 and 1998, I had worked on the restoration of the medieval pulpits in the Cathedral of Ravello. While looking at the seals, I kept thinking of the days spent in the cathedral and in buildings where Michelangelo's friend would have lived centuries earlier, as he nostalgically recalls in some of his later letters. But I knew it was a stupid thought, a product of the irrational subconscious mind, a

typically southern Italian trait, fuelled by magic and supersti-
tion, against which I have struggled all my life. If anything, I
regard these moments of intuition as signs of misfortune,
never of progress of any kind. The echoes of this struggle
reverberated in my head as I looked at the congealed lumps of
sealing wax, which Martin had, somewhat inappropriately,
likened to congealed blood. I grew increasingly anxious as the
minutes passed. Above all, what really worried me was the
idea that these seals contained a key that would help to
unravel the history of the painting. But, even if such a key to
the door that guarded the painting's secrets existed, I did not
know how to turn it.

The laboratory director had vanished. I had sensed his
slight disapproval of my artisan approach, which had under-
mined his sophisticated verdict on the untouched status of
the painting. Every now and then he looked into the labora-
tory to check on my futile attempts to identify the seals, a
situation that was evidently to his satisfaction. I stood up
from the table several times, to look at the view from the
windows. The park that separated the cream-coloured uni-
versity building from the backdrop of brick buildings on the
other side of the road was as wide as an Italian piazza, but
empty and unbelievably clean. The clear light high over the
horizon line showed that here, in late May, spring was in full
bloom, while in Rome the heat would already have wilted the
roses on the Aventine.

Overcoming any sense of embarrassment, I asked for a soft
pencil and tracing paper. I had decided to make a rubbing, the
simplest method of identifying an impression on a flat surface.
Children use this method to copy coins, but it is also fre-
quently used by archaeologists, to make true copies of marble
epigraphs. It was strange that no one had thought of this
before, but I thought it worth a go nonetheless. Louise was

happy to help me and came back a few minutes later with three different kinds of pencil and a ream of different weights of paper. I chose a sheet of paper that was soft but strong. The rim of sealing wax around the seal made it difficult for me to position the paper so as to be able to feel the imprint of the hollow design. Moreover, I could not stretch the paper too tightly because I was worried I might damage the chunky wax, or detach it from the wood.

Very slowly, holding the paper still with one hand, I started to move the pencil gently up and down, trying to keep the strokes parallel and taking care not to overlap the grey shading left by the graphite point on each stroke. Magically a faint mark began to take shape, as I had seen so many times before, when this process was used on a seemingly illegible stone surface. The graphite shading magnified what the eye could not make out. On my third attempt, when my hand had grown accustomed to the weight of the pencil and I had established a constant and even rhythm, the faint impression of a finished form surfaced, like a ghost emerging from the mists of time. What appeared was not Vittoria's column or Beccadelli's winged talon, but three flames crowned by three minute stars.

After a good hour of careful rubbing, I managed to make out this form which, as far as I knew, meant absolutely nothing. I had no idea what the seal might mean or who its owner was. It could have been made at any time during a period of at least three hundred years, and indeed it could have belonged to a Dalmatian family, whose heraldry would be much more difficult to trace. The result seemed so disappointing that, when the time came to go to the airport, I left the papers lying on the table. That I finally took them with me was entirely thanks to Louise – who, without knowing it, played an extremely important role in this story. She ran down the corridor after me and handed me an envelope containing the

rubbings. Printed in somewhat decò black and red letters was
the name: 'Buffalo State, State University of New York, Art
Conservation Dept. RH230, 1300 Elmwood Avenue, Buffalo
NY 14222–1095'. I thanked her and slipped it into my bag.
Martin drove me to the airport. He broached the subject of
the painting by asking, somewhat timidly, what my impres-
sion had been and, with equal hesitation, I told him a little of
what I thought. I hardly knew him, but I was all too familiar
with owners anxious to see a painting's value recognised and
enhanced. Sadly, too, I knew the unscrupulousness with
which they often hurried to publicise an opinion, even one
expressed purely out of compassion. On reaching the ears of
other experts, such opinions were then adulterated, exagger-
ated, dissected and finally returned, often with criticism and
irony, or in the worst cases they were used to prove the dis-
honesty, inadequacy and ignorance on the part of the person
who had voiced them. I tried to imagine what might happen
in the confined world of Michelangelo specialists, which
numbers fewer experts on both continents than you can count
on one hand. My hesitation was also due to the fact that our
relationship had not yet been defined. I did not know whether
I would be asked for an expert opinion or whether Martin
would appoint me to carry out the restoration or research – or
even what sort of agreement to draw up. My visit had been no
more than the whimsical satisfaction of a scientific curiosity,
but neither of us had suggested anything more formal.
Martin's SUV took less than half an hour to reach Buffalo
airport. It was late afternoon and the traffic was slow but
orderly, travelling in three lanes along a lighter coloured
tarmac surface than those in Italy.

At the airport Martin pulled out of his bag a folder contain-
ing all the research that his family had assembled over the
years. It was a body of work to which he had added consider-

ably since his retirement from the air force. There was a certain snobbishness in my refusal to accept work by a non-specialist. Earlier in the day I had heard snatches of conversation about his adventures. When looking at Venusti's copy of the *Pietà* in Galleria Borghese in Rome, he had shown a custodian a photo of his family's painting, claiming that he had in America a much more beautiful painting than the one on display. He had done the same at Galleria dell'Accademia in Florence, where the presence of Michelangelo's sculptures had made him very emotional. In his excitement he had claimed to have a special relationship with the artist. I could imagine all too easily what the custodians had thought when confronted by a crazy tourist who said he had a painting by Michelangelo at home. I could also see the gesture of annoyance made by the museum directors, two women whom I knew well, when the custodians rang to tell them that an American in the museum wanted to talk to them about 'his' Michelangelo. But it was not only this sense of caste that irritated me. The naïvety with which Martin had gone about his research also cast an unflattering light on my own ingenuity.

I had embarked on this adventure with an excess of passion, a sentiment that, like my irrational thoughts, had always been one of my main weaknesses. In order to come here I had left in the lurch one of the most important assignments of my entire career: the restoration of the Piccolomini altar by Bregno and Michelangelo in the Cathedral of Siena, which I had only just started. That world was my reality, and it was already amazing enough to satisfy the most rampant sense of narcissism. But it had not prevented me from flying to America, unable to resist the temptation of seeing a painting that was now adrift in a sea of guesswork, with only a couple of reliable bearings. There was absolutely no question about the beauty and the power of the painting, but I could hardly

start a debate on those grounds. The danger of such subjective judgements is well documented by any number of grotesquely comic attempts at attribution – including the stones attributed to Modigliani, which were then found to have been 'carved' using a Black and Decker. I would never have tried to argue an attribution to Michelangelo based on the quality of the painting. The documents Martin had given me confirmed a family tradition dating back to 1840 that had attributed the painting to Michelangelo; nothing more. It was too little for me to go on; I risked taking a false step.

Even Martin's beige plastic binder, for which he had tried to make a cover using a badly cut-out photocopy of the Boston drawing of the *Pietà*, was an affront to my desperate need for tangible facts and professionalism. It was as if the ingenuity of Martin's research and the poor quality of its presentation mirrored my own credulity and inadequacy at dealing with such a tricky subject. How could Martin not know that Michelangelo, his life and his works, had generated a vast bibliography, and that before you could even think of approaching the artist you would need to spend years digesting this corpus of academic work? How could he think that artistic research had anything remotely in common with Indiana Jones-style adventures? How could he ignore the fact that rigorous research procedures were almost always the only guarantee of reliability? In the same way in which he had lost all credibility in the eyes of the museum directors by accosting the custodians with a photo of the painting, he had now annoyed me by handing me his dilettante research notes.

But even the persistent undercurrents of a childhood immersed in the magical beliefs of southern Italy can contribute to the positive development of research carried out in accordance with the strictly causal principles I have tried to follow since reaching the age of reason. With this in mind, I

accepted enthusiastically the folder from Martin's outstretched hands, not knowing that inside it was a clue that would provide the best lead yet – one destined to get the research off the ground.

8

ON THE FLIGHT FROM NEW YORK

I had planned to spend two days in New York. If the whole business proved a waste of time, at least I would enjoy a brief visit to the city I love most after Rome. I booked a room at the Excelsior on West 81st Street. From there I could walk to almost all the places that interested me, up to the Guggenheim and down to Chelsea, a neighbourhood renowned for its contemporary art galleries. As usual, I walked for hours, until my legs were so stiff I could barely move. On the short flight from Buffalo I had resolved to spend time mulling over some of the questions that had arisen from my meeting, but in the end I only uploaded the photos onto my computer and looked at the disk Martin had given me, with the results of the radiographic and diffractometric tests. I spent the rest of the time enjoying the beautiful spring weather.

Since my last visit to New York, the entire contemporary art gallery district had moved from Soho to Chelsea, between 23rd and 26th Street. This former industrial neighbourhood

has turned into a sophisticated city of the arts, and pretentious fashion boutiques, for the most part Italian, now occupied the old textile workshops along Spring Street. Time and again, I walked in and out of enormous buildings with gloomy iron and brick façades, criss-crossed by narrow, poorly lit corridors, with slanting mirrors to help you spot a potential assassin hiding behind the corner. In contrast to such claustrophobic entrances, the vast empty halls of the galleries themselves seemed even more extraordinary: it was very difficult to distinguish between the artworks, the remnants of industrial fittings, and the classical cast-iron columns painted white, grey or gun metal green.

I came back exhausted every evening and ate at a restaurant close to the hotel. I chose one that had tables on the streets, European style, from which I could enjoy snippets of the lives of Isabel Archer's sophisticated descendants or of those of Henrietta Stackpole, her journalist friend and early feminist. As I replenished my depleted energy reserves, I watched passers-by hurrying between the tall buildings, skittish dogs enjoying their last walk of the evening, and Columbia students, bags full of books on their backs, furiously pedalling home between the lines of taxis and the long menacing trucks. Even this brief stay generated the passion that has always characterised my time in New York.

It was only when the plane started to move off down the runway at JFK that I took out Martin's folder and opened it, lazily. It was like touching a live wire. A charge surged through my body, followed by a pleasant sensation of warmth that spread from the pit of my stomach up the sternum, to my throat, making my heart beat faster. It was like bumping into someone you thought had been dead for years. Before I could make sense of what I had seen, my amazement was overshadowed by a twinge of anxiety. Inside the folder was a photo of

Martin standing in front of Beccadelli's villa on Šipan, the one the prelate had adorned with fresco portraits of his friends, including Michelangelo. Since Marshal Tito had expropriated Church property in Yugoslavia, the villa had been reduced to little more than a ruin for decades. History always comes back with a vengeance in this story. Martin had painstakingly made notes on yellow Post-Its and then attached them to the photos, as a shortcut for proper captions. This one read: 'Beccadelli's Villa, Šipan, Oct. 2006'. I had not realised that Martin had actually visited the villa on his wanderings.

There was another black and white photo on the next page, this time of the villa wall, where Ludovico Beccadelli's coat of arms was clearly visible in high relief, the feathered talon surrounded by an elegant oval moulding with a double cyma. Lower down, almost at the edge of the photo, a plain plaque was visible, rougher than Beccadelli's. The poor quality carving consisted of a short phrase and a hewn-out coat of arms. The incised letters, the shoddy relief, the stonemason's lack of expertise, and even the second-rate quality of the stone were all features that I took in at first glance, but none of these could disguise the astonishing design of the oval coat of arms: three flickering flames crowned by three stars. It was the design I had deciphered only a couple of days earlier, on the wax seals on the Ragusa panel.

The plane turned as it came to the start of the takeoff runway. I stood up to open the overhead locker, where I hoped to find the envelope Louise had thrust into my hands as she ran down the corridor after me. The airline was Italian and a hostess immediately jumped up from the folding seat at the back and hastened down the aisle. I could hardly be mistaken for an American, so she accosted me in Italian. 'We're about to take off, sir. Sit down please and fasten your seat belt.'

In desperation, I mimicked the effects of suffocation and mumbled in a half-throttled voice: 'My pills. It'll only take a moment . . . I've forgotten my pills.' I was not the first passenger to resort to tranquillisers when on the verge of a panic attack. I grabbed my bag and slammed the locker shut before she reached me, and then managed to collapse back into my seat, wearing a suitably miserable expression as I refastened my belt. The plane started to thunder down the runway, and by the time it lifted its nose into the grey sky above the Atlantic I was holding the envelope marked with the university's address in my shaking hands. I pulled out the sheaf of papers containing the rubbings, and there it was: three pointed flames under three stars. There was no question about it: I had identified the seals in the most unexpected and impartial way possible. 'Added to Beccadelli's Villa in 1604' stated the Post-It. The words on the plaque were just legible:

Deiparae nascenti sacram aedem temporum iniuria collapsa[m] M. Fabius Tempestivus anno restituit ac in meliorem formam redegit Anno Do. MDCIIII.

[This year Marcus Fabius Tempestivus restored the sacred sanctuary of the Mother of God, which had crumbled under the injuries of time, and gave it a better shape. A[NNO] D[OMINI] 1604]

The arms, which had been added in 1604, after Tempestivo had saved the building from complete ruin, were crowned by a bishop's hat with six tassels on each side. The discovery enabled the painting to make a jump forward in time that was nearly as great as the distance separating me from the old continent, where I could carry on looking for other pieces of the puzzle.

Having set out on this quest almost playfully, I had gathered all the knowledge I could in America, almost without realising it, and my visit had produced totally unexpected results. To start with, the panel had been adrift in a sea of nineteenth-century uncertainties. Nothing could rule out the possibility that, at some point during the previous two centuries, it had been purchased in Venice or Rome, and then taken to Ragusa by a merchant. But now the situation was different. Here was proof that the painting had been in the Archbishopric of Ragusa in the early seventeenth century, four decades after Beccadelli. Furthermore, at this point it seemed highly likely, almost certain, that Beccadelli himself had taken it there.

My greatest torment at this stage was that I would have to wait at least nine hours before I could tell anyone about this extraordinary discovery.

9

THE BISHOP OF MONTEFALCO

I landed in Rome at dawn, in time to give Marina, Diana and Rocco the presents I had bought in New York and to take the children to school. By half past nine I was sitting in front of the computer with Marina, looking at the photos and at the rubbing of the wax seals. Marina is an architect who graduated with a thesis on seventeenth-century buildings, so it was very difficult to convince her that the theory I had worked out on the plane was actually right. The stone plaque was comprised of two pieces. The upper part, framed by a relief moulding with fillet, cyma recta and neck, announced that in 1604 Bishop Fabio Tempestivo had restored the summer residence of the archbishopric built many years earlier by Beccadelli. Below, on a piece of the same stone, were the arms, framed by two reverse scrolls, which were in turn joined by a small swag of imbricated leaves. I had convinced myself that the arms did not belong to Tempestivo, but to Beccadelli.

I outlined the facts for Marina's benefit: 'Tempestivo

restored the villa, but under his commemorative plaque he affixed another stone plaque, with Beccadelli's own coat of arms, which had been put up earlier by the prelate from Bologna.'

It was a madcap idea, as Marina tried hard to make me understand, but it was also the only way I could establish the link between the painting and Beccadelli. 'This kind of plaque and the design of the scroll are typically late sixteenth century,' she pointed out. 'What's more, the relationship between the two scrolls and the perimeter of the plaque shows that, even if they were made as two different parts, they were designed as one. Moreover, there's no way Tempestivo would have displayed Beccadelli's arms, which are completely different. No bishop would ever reject his own family arms when he became bishop, let alone adopt those of a predecessor.'

It was a perfectly reasonable explanation, but my idea was firmly fixed in my mind. 'What's more,' Marina continued, 'it's quite clear from the photo that it's the same stone. They couldn't possibly have been carved at different times.'

In the meantime, I was searching for a 'Fabio Tempestivo' on the internet, using the Italianised version we had given to his Latin name. The search produced several pages of hits: some were individuals, but almost all were political measures deemed either timely or, for the most part, ill timed. Only two Italian families were called by that name, and we quickly hunted for a telephone number, so we could enquire whether any ancestor might have been a bishop. One family lived in Bari and my question prompted a good-humoured reply: 'My grandfather came back from America in 1945. I'd love to hear of any trace of a bishop among our forebears. As far as I know, our most upwardly mobile ancestor was a baker from Giovinazzo who sold *friselle* in the late nineteenth century.'

Marina made me promise that, if I concentrated my

research on Fabio Tempestivo and on the emblem with the three flames and stars, she would undertake to consult the *Hierarchia catholica*, a volume in the Vatican Archives that recorded the successions of bishops and cardinals in the various catholic dioceses. Of course, the search would be made much more difficult by the communist occupation of Yugoslavia and by the fact that, in modern Dubrovnik, ecclesiastical authority had been annihilated for decades. For the time being, however, all this would have to wait. The comfortable scaffolding I had arranged to have put up was waiting for me, and I needed to start work on the restoration of the Piccolomini altar in Siena.

With its four statues carved by Michelangelo between 1501 and 1505, this was a fabulous but challenging project. Fabulous because, having restored the monument that marks the peak of Michelangelo's maturity, Julius II's tomb in San Pietro in Vincoli, I was now lucky enough to start work on one of the highlights of his youth. Cleaning Michelangelo's statues is certainly not a task you could ever tire of: the prospect of spending the coming days slowly reviving, centimetre after centimetre, marble that had been brought to life by his scalpel is a privilege that many would pay for, rather than be paid to do. But my thoughts kept harking back to the seal, to Ragusa, and to the archives and libraries that, for now, I had no time to visit.

As soon as I could, I made my way to the Biblioteca Angelica in Rome, which houses the world's largest heraldic collection; but I searched in vain. Marina had found a scant mention of Tempestivo in the *Hierarchia catholica*; it gave the period when he had been in charge of the diocese of Ragusa, 1602–1616, but nothing more. The bishop seemed to have disappeared without trace. July and August passed, months when archival research is virtually impossible in Italy due to

the heat and to trade union agreements, which impose monthly closures on archives and libraries alike.

The fast pace of my American discoveries, which all happened within days, was followed by months of disconcerting inactivity. I could not rid myself of the idea that Tempestivo had not played a particularly important role in the story of the *Pietà* and, however mistaken it might be, continuing my research on Beccadelli seemed the only sensible course of action. No researcher should ever underestimate the importance of instinct, even when it appears to run counter to reason.

An opportunity to follow my hunch arose thanks to a fortuitous meeting with Lucio Dalla, the Bolognese singer who has always been my number one musical idol. Since I was fifteen, my life and dreams have been accompanied by the songs of this poetic maestro of Italian music. In June 2008 he came to see me on the scaffolding of the Piccolomini altar, together with Marco Alemanno, a young actor with whom he was rehearsing. I had no idea that Dalla was such a passionate admirer of Michelangelo, and he did not know that I was the author of a book he had much enjoyed. Within the space of a few hours we had taken a liking to each other, and within a few months we were firm friends, something that only happens when you share an all-consuming passion. So alive was this passion that we started to plan a musical composition on Michelangelo for which I would write the lyrics and he the music. Over the following months we met whenever there was a chance. Moreover, when I learnt that Beccadelli's extensive correspondence from Ragusa was preserved in the Biblioteca Palatina in Parma, I decided to take up Dalla's invitation to visit him in order to work more intensely on the project. Besides, during the day it would not take long to travel by train from Bologna to Parma, where I could also work on Ludovico Beccadelli's letters.

10

THE MELANCHOLIC EXILE

I love the private letters that people wrote during the Renaissance. I love their conciseness and the matter-of-fact way in which they switch between matters of state and the most profound ideas, discussing them with a passion for which they often risked death, while also including the most trivial details. For instance, Beccadelli describes 'the fresh melons from Lunghezza which arrived the day before yesterday', 'the excitement of the Carnival festivities', 'a bout of catarrh I can't shake off', and 'the memory of the wonderful summer that you, Monsignor Pole, and I spent at the villa in Pradalbino'. As I turned the pages of Beccadelli's letters, I was not only looking for information about Michelangelo's painting. I was fascinated by these documents, which mapped the destinies of men who had generously hoped to change the world but had paid a price for their ambitious plans. Indeed for the next three days I was so passionately absorbed in the manuscripts that I did not even find time to visit the Palazzo Farnese.

As I walked from the railway station to the Palazzo della Pilotta every day, I was struck by its disproportionate size compared to the rest of the city. It made me ponder on the nature of Italy, this land of over-exaggerated ideals and excessive ambitions, which punish the individuals but leave grandiose marks on their surroundings. This huge palace is a case in point: an entire cavalry regiment could easily have ridden up its staircase. Through the half-closed doors of the atrium, which are shared by the vast theatre and by the Palatine library, I peeked into the perfectly rational, perfectly conserved auditorium at eight in the morning and wondered whether there had ever been enough people in the city to fill it entirely. The grandeur of the architecture was gauged solely on the grandiose ambitions of the city's rulers. Then I walked into the deserted but equally grandiose library, filled with eighteenth-century shelving that towered up to a gilded ceiling. It was a room that other rulers would have used as an elegant ballroom, but the Archduchess Maria Luigia of Austria had dedicated it to books; and now it was empty. I crossed the polished, silent halls, promising myself that I would explore them at leisure later; but that moment never came.

When I sat down in the small, anonymous manuscripts room, which was supervised by a kind librarian, I was immediately drawn into the story of those young students from all over Europe who had met at the University of Padua around 1530 and developed a brotherly friendship based on their common desire to reform the world. Just like young people in any country and age. During the summer holidays they gathered at their family villas for interminable discussions during which they would put the world to rights, seated on the warm grass, in a world apart, where the study of poetry and ancient history conjured up real feelings and passions not yet corroded by cynicism.

Seen from the purely private viewpoint of their individual feelings, the story of the *spirituali* is hardly an original one. It has repeated itself thousands of times, through endless generations all over the world, and goes on being repeated today. What makes this group of friends different, however, is the historical setting with which they were so inextricably entwined: the Reformation, the most violent religious conflict in western Europe. The letters clearly show how Ludovico Beccadelli, having reached Ragusa after a disastrous sea voyage that lasted twenty-six days, tried to govern the small, isolated republic by prudently mitigating the religious principles that had led to his exile. At the same time he tried to follow the events and to preserve his ties of friendship with other members of the group, although this became increasingly difficult under the relentless persecutions imposed by their main adversary, Pope Paul IV. Beccadelli wrote constantly to Pole's secretary, Alvise Priuli, asking for news and giving his own; he also peppered his letters with news of other friends. In the melancholy of his exile he recalled the glorious period of their studies, now mythicised through the passage of time. Yet it was these memories, together with his love of letters and art, that enabled him to survive those years.

I had come across many of these men in other letters and in books. Some had become old acquaintances; others had had their faces immortalised in paintings by Titian and Sebastiano del Piombo. A few were just faceless names, but these were the most exciting ones because I could give them faces of my own choice, pieced together from the character traits I found in their letters. But, as I continued to read the letters and the daily chronicle of events in Ragusa, a new figure whom I had never met before started to take shape: one 'Padre Crisostomo' who was always at Beccadelli's side, always present at his

orations and involved in the spiritual government of the wild
Dalmatian republic.

From the letters it is clear that Padre Crisostomo was an
old acquaintance of both Priuli and Reginald Pole, because
Beccadelli constantly refers to his presence, at times mention-
ing his thoughts or a suitably spiritual action, and in turn
Priuli refers to Crisostomo and his independent correspond-
ence with Pole and with himself. The letters depict this man
as a very close mutual friend, whom Beccadelli met again in
Ragusa and with whom he shared happy memories. I had no
idea who this man was or what role he played in Ragusa, or
indeed in the group, but it became clear that this was another
figure linked to Pole, who had lived in Ragusa during that
period. Moreover, here was another possible person who
could have brought Pole's painting to the city.

Beccadelli's movements around 1560 can be accurately
traced through the letters. When Pole died in 1558, Priuli
started to make his way slowly back to Italy, but the situation
was not yet safe. Pope Paul IV was still alive in Rome, where
he continued to persecute their old friends. At one stage, he
even imprisoned Cardinal Morone in Castel Sant'Angelo.
This was a step that few other popes had taken, except when
cardinals had openly plotted to kill the pontiff.

Priuli was carrying Pole's 'relics' back to Italy, where they
were meticulously shared out among the old members of the
group. Beccadelli confirmed this by writing that Priuli 'only
kept for himself the breviary with which the saintly man said
mass'. Similarly Carlo Gualteruzzi, a mutual friend and
another of the well-known figures who served in Pole's
household [famiglia], was delighted to inherit a stable and a
kitchen garden that had belonged to the English cardinal in
the Belvedere. Priuli travelled slowly to Padua and Venice,
where he debated whether to set sail for Ragusa and join his

two friends. He expressed the desire to visit them and bring the 'relics' with him, repeatedly stating – how truthfully it is not known – that he would like to spend the rest of his days in that island of peace.

Ludovico Beccadelli did not share his conviction. Their enemy Paul IV finally died in 1559, and he was succeeded by a Medici pope who had long been Beccadelli's friend. Their common friends in Rome insisted that he should travel to Rome immediately. Citing decidedly unspiritual motives, they begged Ludovico to hurry because competition for the prestigious posts at the papal court had already begun and, if he arrived late, he would have to make do with a less profitable position. Beccadelli decided to travel to Rome in the autumn of 1560, leaving Ragusa with the idea of returning in a few months' time, yet secretly hoping never to see the city again. On arrival in Rome, he learnt that Priuli had died in Padua in the summer of 1560. Padre Crisostomo was left in Ragusa to oversee the archbishopric. If Priuli had managed to bring the painting from London in order to give it to Beccadelli, the painting would have arrived in Ragusa after the bishop had left, and Crisostomo would have been the one to receive it. It is time to bring Padre Crisostomo out of the shadows.

11

THE LAST SURVIVOR

When I went back to Siena to continue work on the Piccolomini altar, the scaffolding was the best place to reflect on the dozens of letters I had read in Parma. From eight in the morning until seven in the evening, I was alone with Michelangelo's statues, slowly removing the layer of grime that obscured their beauty. Michelangelo carved marble by modelling it like wax. The hardness of the stone is never apparent in the chiaroscuro passages, whether they take the form of folds, thrust up by the underlying muscle, which then flatten slowly if the garment is made from heavy cloth or suddenly in the case of a silk or cotton shirt. Bulges and hollows fade with imperceptible smoothness, as if they were real flesh and real fabric, not hard stone. They seem to be the effect of light alone, not of matter. This is why Michelangelo chose perfectly white marble, which would not interfere with the gradual transition from light to shade. Grime and the lamp-black of candles accreted on the marble over centuries conceal

and violently deaden these statues until only their general features are perceptible, the darting outlines, the perfect profiles, but not the inner luminosity which is the truly incomparable quality of his work.

By returning the marble to its original colours and chiaroscuros, cleaning becomes a process of revelation, as the sculpture is reborn. Using only very gentle procedures involving distilled water and cotton wool, this cleaning method is extremely challenging for the restorer, because the same amount of filth must be removed uniformly, without creating new imbalances that would appear as false shadows, interfering with the real ones carved by the sculptor's chisel. At the same time, over the centuries the marble acquires a golden patina, which hides and slightly deadens the workmanship of the original stone. This patina can be removed during cleaning, and the process of undermining this new 'skin' leaves paler areas that, like the false shadows of grime, interfere with the original chiaroscuro of the relief.

The slow but steady results of reinstating the marble surfaces were very satisfying, and even the proximity of the statues, the perfection of the carving and the beauty of their forms generated, as always, a feeling of wellbeing that relegated every other requirement, even physical ones, into second place. Indeed, sometimes I would even delay my lunch break, minute after minute, and not stop until evening. If one were to continue working in this exalted state for any length of time, it would certainly be bad for one's health; but when the exaltation is concentrated within the space of a few months, it allows the art restorer, for a brief interlude, to experience a state of true bliss. I imagine an actor experiences the same feeling while shooting a film with a legendary producer. The feeling of being responsible for the recreation of such absolute beauty gives one the illusion of being, even if

temporarily and in a minor way, responsible for that same beauty.

As I worked, I went over every minute detail of the story, being constantly accompanied by these same marbles in an ideal, silent dialogue. Beccadelli's letters not only confirmed that he left Ragusa in the autumn of 1560, but they also provided an answer to the key question I had first raised months earlier. In the likely event that the painting was sent to Ragusa as part of Pole's inheritance, Beccadelli did not take it with him when he left for Rome, because he had not received it. Beccadelli was a collector and a friend of Michelangelo, but he was also the most 'venal' of the group, as Pole and his friend Priuli had commented in a jointly written letter from London.

Beccadelli was extremely sensitive to social flattery, and both Pole and Priuli saw his exile as a divine blessing, since it would protect him from the temptations of worldly ambition. They could not know that even divine blessings come second to human desires and that, as soon as he had a chance, Beccadelli would return from exile and throw himself back into the competition for curial office, albeit to emerge defeated and with a second-rate benefice: the *prepositura* [provostship] of Prato, where he spent the rest of his days. His departure from Ragusa before the painting had arrived would therefore explain why he had not brought it with him to Italy; but it did not yet explain why, four years later, he did not arrange for it to be sent, once it was clear that he would never return to Ragusa.

The letters also opened a new lead. Who was this saintly figure, Padre Crisostomo, who seemed to hover like a divinity above the heads of Beccadelli and Pole? In the historical accounts of the *spirituali*, Ragusa only appears as a temporary place of exile for Beccadelli, but the letters showed that there

was at least one other thread tying the group to the city: Crisostomo. The name had given me the idea that he was a Greek priest whom Beccadelli had met in Ragusa; but why would he write to Pole reminiscing over the time they spent together? Where exactly had they met, and why? There were two historians who could help me in my research: Thomas F. Mayer and Adriano Prosperi. The former, an American professor, is the leading biographer of Reginald Pole, and I had had an opportunity to meet him while filming a documentary on the circle of the *spirituali*, on which we were both working. The latter, professor at the Scuola Normale Superiore in Pisa, has written the most in-depth studies of the Italian Reformation in mid-sixteenth century, including the circle of the *spirituali*. I had known him for years, since the time I had first put forward the hypothesis that Michelangelo's work on the tomb of Julius II in San Pietro in Vincoli testified to his own support of the group's devotion. He had backed my thesis and had also generously helped me, first by organising a shared lecture at the Accademia dei Lincei in Rome, and then by writing the preface to my first book on Michelangelo. I wrote an email to Mayer to which I received a polite reply, saying that he had no idea who this Padre Crisostomo was.

Then I went to visit Prosperi in Pisa, leaving Siena one blistering afternoon in September. Once again, he was extremely generous. He said that he had come across Crisostomo at the Council of Trent, alongside Pole (this was excellent news in itself), but he knew little more than what he had already mentioned in one of his books. However, he gave me a new lead: the Vatican Secret Archives contained a document recording an apostolic visitation of 1573. Ten days later I finally managed to visit the Vatican, where, before starting to look at the voluminous bundle containing the records of the apostolic visitation (1,600 manuscript pages), I again

consulted the century-old catalogue of catholic bishops. I made an unexpected discovery.

In spite of his exotic name, Crisostomo Calvini was a theologian from Calabria, named Tommaso at birth. He had been made Archbishop of Ragusa in 1565, after Beccadelli decided not to return to Dalmatia, and then had died there in 1575. Therefore, although he had vanished from European historiography on the *spirituali*, he was indeed a leading figure who had controlled the diocese of Ragusa for fifteen years. The apostolic visit offers a full picture of Calvini's spiritual profile, at least from the point of view of the Apostolic See – which, having received a variety of complaints, both anonymous and less so, sent an inspector to Ragusa in 1573, to gauge the situation. The reports of the visit form a perfect example of the political-police character of an investigation undertaken by a power in order to control its periphery.

The apostolic visitor drew up descriptive reports with what seems, to our eyes, a level of meticulousness verging on the maniacal. He entered every church in the city and made a detailed list of all the objects inside them, which then doubled as an exhaustive inventory of ecclesiastical property. But, alongside the general inventory, he also recorded the minutes of the interrogations to which both the clergy and lay officials were subjected. What is truly surprising is that the apostolic visitor also recorded anonymous accusations, gossip, disclosures made in confidence and anything else that might help to reveal the complexities of what was really happening in a particular situation. Lastly, the apostolic visitor – Gian Francesco Sormani, Bishop of Montefeltro, in this case – was an extremely competent figure, carefully selected for his perspicacity and loyalty to the Apostolic See.

In short, the visitation served as a sort of ruthless magnifying glass through which the central authorities analysed every

detail of its peripheral domain. Of course, for a modern historian a pastoral visit is an extraordinary tool for exploring contexts, places and personalities; and, more pertinently in this case, the bombastic report also offers a minute description of Crisostomo Calvini, the city of Ragusa and the precise nature of Calvini's spiritual control. The report suddenly brought to life a figure who had been forgotten by modern historiography. Moreover, the picture is completed by a seventeenth-century chronicle of the Archbishopric of Ragusa, which is preserved in the Biblioteca di San Marco in Florence.

12

RAGUSA, 1573

In 1573, the city of Ragusa had been an independent republic for over a century, being governed by a patriciate comprised of the leading merchants and shipowners who controlled the Mediterranean trade. With its dry, wild hinterland, the republic might well have been an island, not a promontory, enclosed as it was within the city walls and relying exclusively on sea routes for communicating with Italy. The visitor's impression was that of a remote centre, where ecclesiastical law was altered to suit the powerful patriciate. But the worst accusation levelled against the ecclesiastical administration and Archbishop Calvini by the Rector of the Ragusan council was as follows:

> Our cathedral church is not well attended by the canons themselves [. . .] and in the processions, which are often shameful to see, the Church of God is abandoned by its ministers, something that is both scandalous and a bad example.

[. . .] The Archbishop is a monk of Calabrian origin, and an innocent and good man, who was transferred in 1563 from the Order of Saint Benedict in the province of Ragusa. However, while he may be good at running a monastery, as an archbishop he is weak, both in spirit and in administration, especially in this free city with its insolent priests. He neglects his duty, to the great detriment of his subjects; due to his faint-heartedness he does not try to punish the delinquent priests, so they remain unpunished and cause shame to the good ones. [. . .] He has never called a council [. . .] he promotes priests who have no property at all in the world and does not give them benefices. Therefore, in order to live, they are obliged to commit many indignities to earn money, and he tolerates that secret marriages are contracted at every level.

According to his accusers – who may, however, have felt some personal sympathy for the man, as the rector did – Calvini focused entirely on the spiritual concerns of his flock and avoided anything related to temporal affairs. Many priests took advantage of his goodness and generosity – above all, those who had powerful families behind them. This led to public outrages on an abominable scale, like the disgrace inflicted by a homosexual canon who lived publicly with boys, flaunting his sexual predilections and even baring his backside once during mass, just to spite his enemies. But the main charge brought against Calvini was that he had never called a council or a synod, thereby avoiding the need to implement the dictates of the Council of Trent. 'He does not enforce any aspect of the Sacred Council; nothing has changed in Ragusa after the Council.' Indeed why would Crisostomo Calvini have accepted the principles of a council that had dashed his hopes for renewal, hopes that he shared with Reginald Pole and the other *spirituali*?

Tommaso Calvini had been earmarked by his family to become a doctor of law, but he soon realised that he had an impelling religious vocation. Once he had entered orders he even changed his name to Crisostomo, in homage to St John Chrysostom's vocation for preaching. Calvini studied in Padua and later lived at the convent of San Giorgio in Venice; there he was a contemporary of Reginald Pole, who became his friend, and they shared the same teachers. Calvini was much better trained in theology than Pole, and he certainly made an important contribution to the elaboration of Pole's doctrine. Unlike other group members, many of whom had a humanist and lay background and had been involved in the debate on ecclesiastical affairs through less highbrow channels, Calvini wielded his specific expertise in defence of the new theological questions during the struggle at Trent, as well as during the earlier more subtle battles.

The Benedictine monastery of San Giorgio in Venice was one of the main centres where the theology underlying the *Beneficio di Cristo* was developed. Calvini had such a gift for theology that the Benedictine order made an exception to its rule of not appointing anyone under forty as abbot – specifically for the purpose of ensuring that this young monk could be sent to the Council of Trent to defend the reforming theology that had matured precisely within the Benedictine setting.

At Trent, Calvini became very close to Pole and he played an extremely important role in their shared battle, as his intellectual biography seems to suggest (he produced many texts, including a commentary on the psalms of St Dorotheus). Unlike almost all the other leading members of the group, who were linked to and constrained by secular power in various ways, Crisostomo was a man of absolute purity and ascetic strictness. When he realised that the suggested reforms of the

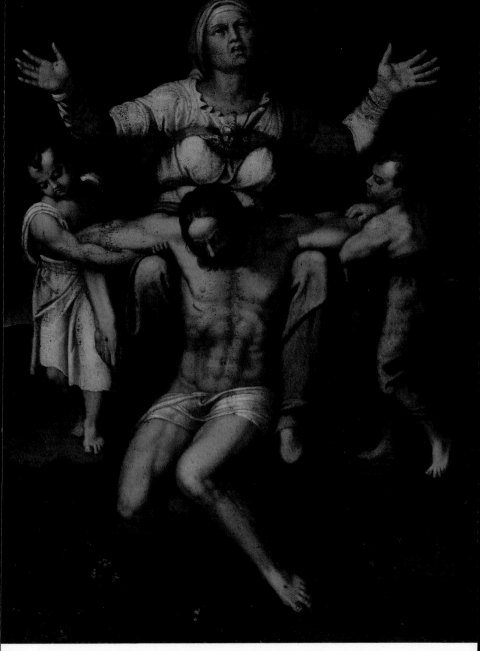

Michelangelo Buonarroti, *Pietà* for Vittoria Colonna, 1545–46, oil on panel,
64 × 48 cm. Private Collection. Christ's face, chest and right arm have been altered
by repainting during restoration. The dark background of the panel is entirely
painted over, as are all the shadows.

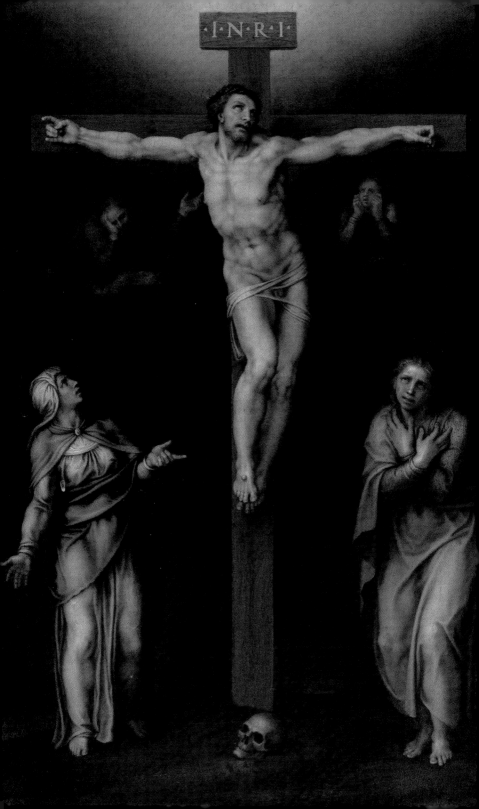

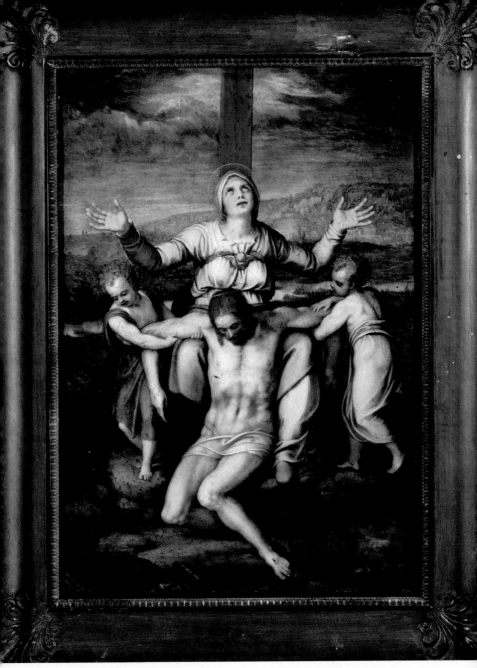

(Opposite) Michelangelo Buonarroti (?), *Crucifixion* for Tommaso Cavalieri with the Madonna, St John and two mourning angels, oil on panel, 51.4 × 33.6 cm. Private Collection, Oxford. Formerly owned by Cavalieri family.

Marcello Venusti (?), *Pietà* (after Michelangelo Buonarroti), oil on panel, 56 × 40 cm. Galleria Borghese, Rome.

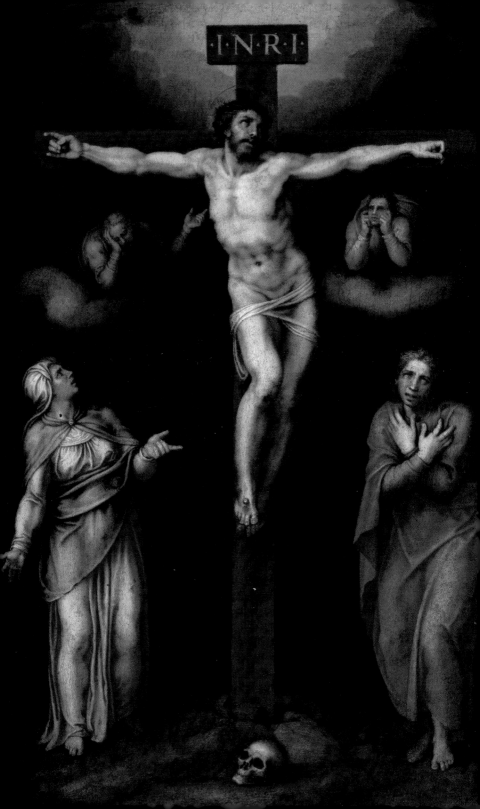

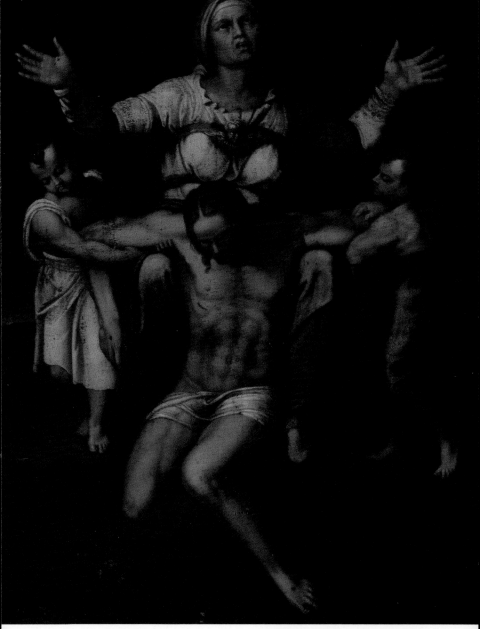

(Opposite) Marcello Venusti (?), *Crucifixion* with the Madonna, St John and two mourning angels (after Michelangelo Buonarroti), oil on panel, 51.6 × 33 cm. Galleria Doria Pamphilj, Rome. © Arti Doria Pamphilj srl.

Virtual rendering of the *Pietà* by Michelangelo which shows the painting without the repainted areas revealed in the reflectography and x-ray images.

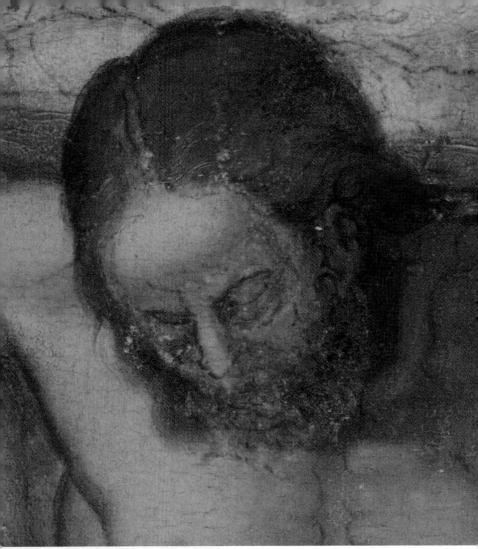

(Above) Close-up of Christ's face as it appears in the reflectography of Michelangelo's *Pietà*. The darker marks caused by repainting have been eliminated to highlight the original underdrawing. During the nineteenth century restorers turned the foreshortened cheekbone into an eyelid after radically cleaning the shaded part.

(Left) Close-up of one of the red wax seals on the back of the Pietà panel.

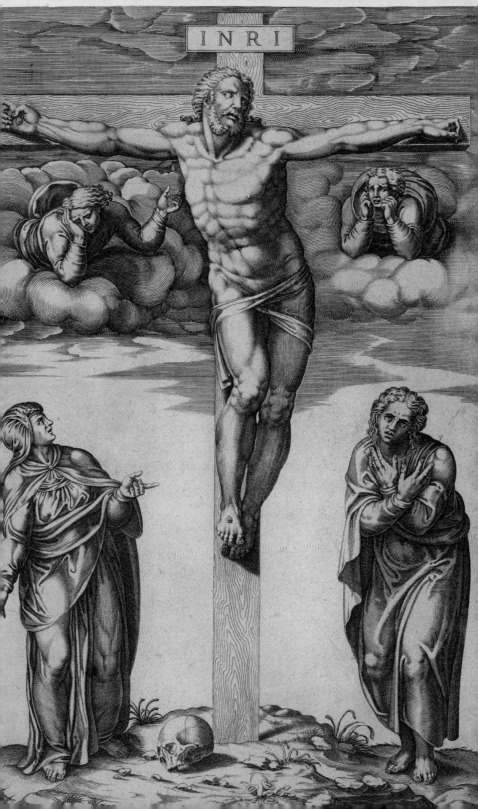

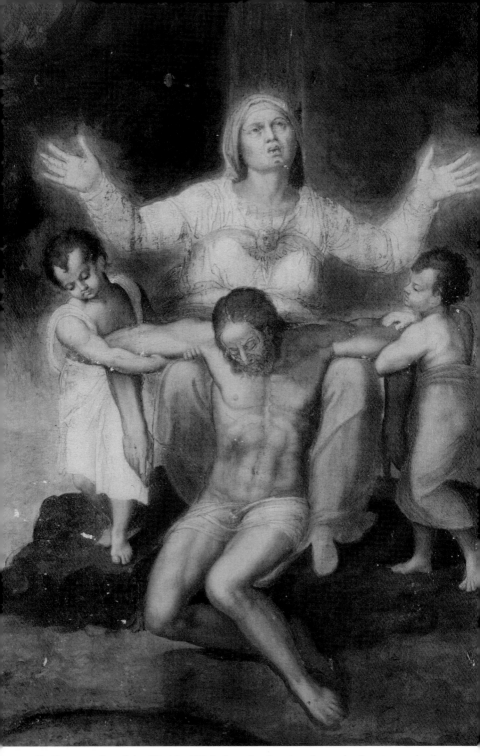

Reflectography of the *Pietà* by Michelangelo showing the underdrawing and subsequent repaintings.

Church had been rejected, he made the only choice that would allow him to go on dedicating his life solely to his faith in Christ.

In 1550 he left Italy and retired on the island of Melita, thirty miles from Ragusa, where he was in charge of the Benedictine monastery and its subordinate houses under Ragusan jurisdiction: 'During the fifteen years when he was in charge of the said Congregation, he increased and expanded both the buildings and the holy customs of the monastery, as well as the temporal revenues.' This is the portrait given by a diarist who wrote the Ragusan chronicle. Calvini's choice to dedicate his life to his faith is wholly in keeping with the accusations made against him during the time when he was in charge of the city. In the course of his defence before the apostolic visitor, Calvini continued to assert his own purely spiritual vocation. 'By grace of God I am a theologian and I have preached and read St Paul's epistles many times in public, but now, because I am old and lack teeth, I cannot speak the words clearly and therefore I do not preach or read any more.'

Saint Paul's epistles are those referred to by all sixteenth-century reformers, from Luther on. Even in distant Ragusa there were members of the congregation who found the sermons on Saint Paul too offensive, and the scandal of an anonymous letter left in the cathedral pulpit reached the ears of the apostolic visitor. The letter had accused Calvini of heretical leanings and then threatened to blackmail him. Even in Ragusa, it was not easy to stop the progress of history or to stem the changes that required everyone to take sides. Calvini showed stubborn resistance: he hoped that his own life would act as a spiritual guide for his congregation. He refused to call the synod to ratify the council, and he tolerated clandestine marriages and the circulation of free ideas. Moreover, as two

local librarians confessed on separate occasions, he even failed to check the lists of books imported from Venice. This was more than enough to have him removed and burnt alive in Rome, on the bridge of Castel Sant'Angelo or in the piazza at Campo dei Fiori. Luckily for Calvini, nature showed greater clemency than the papacy.

The outcome of the 1573 visitation was that charges of heresy were brought against the last of the *spirituali*, that obstinate group of intellectual heretics whose infectious zeal had spread like a contagion through the most liberal elites of mid-sixteenth-century Italy. Even noblewomen had become involved – like Giulia Gonzaga, another of Ercole's cousins, who would have gone down in history merely as the most beautiful woman in Italy if her prodigious beauty had not concealed an equally rare passion for reform. But the sole survivor of the *spirituali* had already been seriously ill when the visitation started. As the visitor noted, the interrogation had taken place in the archbishop's palace because the interested party was confined there by gout.

That attractive palace had been built by Beccadelli using the latest classicising styles in vogue in Italy. It stood opposite the cathedral and was surrounded by affluent but outmoded fourteenth-century palaces that, to a Renaissance man of Beccadelli's refined tastes and social sensitivities, would have seemed appallingly ugly. It would have been difficult to ask Crisostomo to undertake the sea journey to Rome, when he had not even managed to cross the street. All in all, it was more judicious not to create a scandal and to wait for nature to take its course: indeed, just over a year later, in 1575, Crisostomo died as he had lived – in poverty.

It would take another twenty years before the Church in Ragusa was put to rights, this time by Fabio Tempestivo, a perfect exemplar of the reformed Catholic Church. As soon as

he arrived, he called a meeting of the synod so that the local churches were obliged to ratify the new Tridentine principles. The apostolic visitor continued with his task, scrupulously describing the city and the churches one by one. There is a hint of desperation in the description of altars that are uncared for or deconsecrated, or endowed with miserable furnishings that amount, at best, to a couple of small icons or wooden sculptures. The Italian Renaissance with its magnificent churches, altars and statues seemed a long way off. Only in the cathedral was the apostolic visitor amazed to find a famous Titian, which he recognised. The reason why the sacristies had no books, chairs or communion cups was always the same: there were no Church revenues in this desolate place, the priests complained. Ecclesiastical control was overawed by the wealth and power of the merchants, and the republic's isolation made it difficult to achieve a balance of power. At times. the city seemed to have sunk back into the middle ages, yet it was also influenced by the ongoing turmoil through Venice – its nearest source of fabrics, painted furniture and, more importantly, books that carried new ideas.

The tales of those who knew Ragusa paint the picture of a city subject to strict reciprocal control, imposed by the inhabitants themselves. Space was limited and everything happened on the same narrow stage. Vices and virtues were inevitably subject to scrutiny, and forbearance was a valuable gift that could stop perennial family rifts. The minutes of the apostolic visit reveal a fascinating description of a world which was *conclusus* [enclosed], a stone stage barely large enough for the disentangling of these clashes and passions, surrounded by the sea that cut off any chance of flight. For the story that I was trying to piece together, the record of the visit was a mine of information.

Crisostomo Calvini was a man of enormous stature in

Pole's eyes, almost an invention of his own extreme spirituality. The two shared a number of traits. In particular, an indifference towards luxury and worldly pleasures: like Pole, Calvini 'kept neither chamber nor court'. He dedicated his entire life to meditation and to the true faith, choosing to live far from Italy – not as an exile, as in Beccadelli's case, but in order to serve God. Perhaps even by the time he left Trent, Crisostomo Calvini had been singled out as the most worthy recipient of the *Pietà*, which Vittoria Colonna had given Pole (and which Pole had offered Gonzaga) as a relic and testament of faith. It cannot be ruled out that, when Calvini left Italy for the islands of Dalmatia, the closeness and reciprocal love between him and the English cardinal meant that the latter decided to give him the painting. Pole may have hoped that the painting would strengthen Calvini during his evangelical mission; Vittoria had given it to Pole himself, prior to the difficult days of the council, in the same spirit: to fortify him for the battle, which Calvini had also actively fought at his side. On the other hand, if Pole had kept the *Pietà* and taken it to London instead, after his death it would have been natural for Priuli, who only wanted to keep the cardinal's breviary for himself, to send the *Pietà* to Calvini, because, of all the members of that group, Calvini was certainly the one who would have valued it most. After reading the Vatican document, yet another piece of this complicated jigsaw puzzle fell into place, through the history of the *spirituali*.

Pole's inheritance had been shared out between his friends, who were also members of his household, as the minutes of the Roman Inquisition scornfully note. Carlo Gualteruzzi had received a stable in the Vatican; others, including Beccadelli, undoubtedly received books. The painting was reserved for Pole's most spiritual successor, and almost certainly that person was Crisostomo Calvini.

The *Pietà* had gone where it was supposed to go: it had followed Pole's successor to Ragusa. A trip to Dubrovnik might now solve the remaining unanswered questions. For example, what role had been played by Tempestivo, the bishop whose seal was stamped on the painting? My first impressions seemed to cast him as the liquidator appointed to remove any trace of the theological heritage of the *spirituali* and to bring Ragusa within the new order created by the Council of Trent.

13

THE MADONNA'S TEETH

Now, as I retrace these events, following a journey that was intellectual as well as geographical, I realise that there was a circular pattern to my research: it always started in Rome and returned there, at which point familiar objects took on new meaning in the light of what I had learnt elsewhere. A perfect example is the painting of the *Pietà* attributed to Marcello Venusti, which for centuries has been regarded as the best translation into painted form of an idea initially sketched out by Michelangelo and then immediately turned into an engraving by Bonasone. The small *Pietà* can be seen in Galleria Borghese in Rome, but its provenance is unknown. According to the critics, and on the basis of Vasari's account, Venusti, of his own accord, translated into painting both of the themes that Michelangelo had explored in his drawings for Vittoria Colonna: the *Crucified Christ with the Virgin and St John* and the *Pietà*. There is even a copy of the *Crucifixion* in Galleria Doria Pamphilj at Rome, and another, again attributed to

Venusti, in Florence. A third version, in Oxford, is hardly ever taken into account.

Having returned to Rome after my American trip, I immediately decided not only that the painting of the *Pietà* in Galleria Borghese was inferior in quality, but also that it was based on the painting in America. Although at first glance they look alike, a number of formal aspects are resolved in different ways. In the Borghese painting, the feet of the angel standing on Christ's left are aligned along the horizontal plane, producing a grotesquely deformed posture. In order to give a correct impression of spatial depth, the angel's left foot should be closer to the viewer than the right one, as in the American painting. Another anatomical oddity that immediately struck me in the Borghese copy is that Christ has a strangely swollen knee instead of the complex joint shown in the American painting. The presence of the symbols of passion – the crown of thorns, the hammers and nails – at Christ's feet in the Borghese painting shows the degree to which the scene had been standardised into devotional melodrama, whereas the original model allowed the viewer to identify emotionally with this mournful occasion.

At this stage of his life Michelangelo did not tolerate melodrama of the kind generally used in sacred plays. Indeed the artist refused to paint the nails that held St Peter suspended on the cross in the fresco of the *Crucifixion of St Peter* he painted for the Pauline Chapel in the Vatican. While this discovery was only recently revealed, it had already been surmised from a number of contemporary debates. This minor revolution was one out of many which foreshadowed modern conceptual art.

While the counter-reforming prelates were meeting at Trent and debating, among other subjects, the need for artists to adopt a mandatory educational narrative when they portrayed

the lives of the saints, in order to ensure their comprehension by the common people, Michelangelo embarked on his most extreme challenge yet: he erased any anecdotal feature, any naturalistic simplification from his paintings. Defying the laws of gravity, Peter is held fast on the cross without nails, purely by the strength of his own faith. It is precisely this troubling absence that forces the viewer to question his or her own belief and to analyse the emotions aroused by the image. This was blatant intellectual provocation. The landscape vanishes, as does all historical reference in the garments. The drama of faith is eternal, without time or place, as is summed up by the extraordinarily expressive quality of the figures.

The message of the Ragusa *Pietà* was identical, but it was a message that only a few would have understood. Vittoria Colonna was certainly one of them, because she had helped to create this new language. When Venusti copied Michelangelo's painting, he was aiming at a less selective group. He instinctively tended to make its meaning more ordinary, adapting it so that it would be more widely understood; in short, he turned a complex message into a simple one. Hence, in the Borghese copy, we see the appearance of the nails, hammer and crown of thorns, as well as the addition of haloes for the Madonna and Christ; and we see the appearance of streams, little houses and rocks silhouetted against the sky. These are means whereby a bitter provocation is rendered more palatable.

This is also the line taken by Bonasone in his engraving of Michelangelo's drawing. Rome, which preserves every fragment of its history, has also kept a fine copy of Bonasone's engraving at the Calcografia Nazionale, located behind the Trevi fountain – whose noise can be heard while you view the collection. One important aspect is apparent at first glance: the group of figures is exactly half the size of those in the Ragusa painting or in the Borghese copy. This raises the pos-

sibility that all three shared a common model. The drawing of the *Pietà* conserved in Boston, again attributed to Michelangelo, is also nearly of the same size, thereby presupposing a common origin. In all, there are four copies of the same subject – two paintings, one pencil drawing, and one engraving – but countless suggestions have been made regarding their reciprocal links, both genetic and chronological.

There was a way to obtain new information that would throw light on this comparison. It meant carrying out an infrared analysis of the Borghese painting in order to examine the underdrawing of the *Pietà*. The infrared image of the American painting was already available. An analysis of both underdrawings would add weight to any comparison between these paintings, Bonasone's engraving and the Boston drawing. It then struck me that it would be much simpler to spot the differences between the various paintings by extending the analysis of the underdrawings also to the *Crucifixions* attributed to Venusti. Moreover, this would also allow me to rule out Venusti's part in the American copy, once and for all. This was how I came to analyse the underdrawings for all three *Crucifixions* in Rome, Florence and Oxford.

The plan I devised was perfectly reasonable; but it would be difficult for an expert not attached to an institutional programme to carry it out. So I decided to outline the study to some scientists with whom I had worked over the years in the various restoration laboratories. I talked to Franca Persia at ENEA [Italy's National Agency for New Technologies, Energy and Sustainable Economic Development], because she has years of experience in the field of infrared reflectography. I asked whether she would be willing to use her expertise and laboratory equipment on a research project that was proving very interesting. She needed little convincing. It is extremely rare for the documentary research to tie in with the

material facts, and their combined fascination made it hard to turn down an invitation of this kind. The reasoning was straightforward: the underdrawing has always been a decisive factor when examining copies. Copyists focus their efforts on the painted quality of a painting, reinstating the identical forms and the colours, but the artist feels freer to use his own methods in the underdrawing. More particularly, significant clues to the artist's identity are offered by the *ductus* [cluster of features which make an artist's brushstrokes unique] and by the quantity of information it provides: for example, a hand can be delineated by using ten lines or thirty, depending on the artist's skill. The discovery of the underdrawing, with its secrets, has given us the true modern method of distinguishing between copies and originals, whether by Caravaggio, Rembrandt or Raphael. Therefore, however ambitious, this project was amply justified and we managed to convince the museum authorities to grant us permission to carry out infrared reflectography tests on the paintings.

In the case of Venusti's *Pietà* at Galleria Borghese, an important discovery was made before we even started the tests. The painting is kept in a 'clima-box', a climate-controlled frame whose glass makes detailed observation difficult. Owing to the chronic lack of museum staff and in view of my experience as a restorer, we were asked to take apart the protective frame and to remove the glass on our own, on a Monday morning when the museum is usually closed. All the tests had to be completed during that morning. We arrived at the closed doors of the museum at eight o'clock sharp. In our dual role as scientists and workers, we brought with us various highly sophisticated pieces of apparatus, but also a toolbox. We took the painting off the wall and started to remove the glass. When we were able to look at the small panel in good light, without any reflection, I noticed that between the Virgin's half-parted

lips were two minuscule white dots, two barely visible teeth. Those teeth were irrefutable proof that Venusti had copied the American painting without understanding its crucial details. Michelangelo, faithful to an expressive language which dated back to the time when he had painted the Delphic sibyl, and which was reaffirmed in many figures in the *Last Judgement* and the Pauline Chapel, deliberately allowed the teeth to show in order to emphasise the sensuality, the humanity, and the tangible nature of his figures. In the Ragusa *Pietà*, the teeth are very evidently the expressive focus of the Madonna's face. Because they were so small, the Madonna's teeth could not be seen either in Bonasone's engraving, of which I had a photographic copy with me, or in the Boston drawing. Therefore Venusti could not have copied this detail from them – and even less so if the Boston drawing is really Michelangelo's autograph work. Yet when he painted this replica from an original model by Michelangelo, Venusti had thought it necessary to include this detail. But, because he did not understand the master's creative language, he reduced the formal importance of the detail, making it almost insignificant and visible only on close inspection, to someone holding the panel in their hands, as I was then doing. Indeed, I had already been dozens of times to see the painting on display, both before and after my trip to America, without noticing this tiny particular. Where had Marcello Venusti seen this detail, and why had he deemed it necessary to include it, even if he had not succeeded in giving it adequate expressive importance?

The only explanation was that Venusti had seen the Ragusa *Pietà* in Michelangelo's own house, and that he had started to copy it before the painting left Rome. And indeed, further confirmation was to come after the completion of the reflectography tests.

14

THE HIDDEN DRAWING

In order not to interfere with the scientific rigour of the tests carried out by the ENEA specialists, I did not show them the American reflectogram until they had completely finished. But when the underdrawing of Venusti's *Pietà* appeared on the screen of the computer hastily installed in the air-conditioned storage rooms below Galleria Borghese, I could hardly contain my excitement, because it was so different from its American twin. Venusti had used a pouncing technique to transfer his drawing, and had then joined the charcoal dots with a very watery brush. The edges of the drawing were very soft, full of light and shade, almost like a watercolour in which the artist anticipates the final chiaroscuro of the images. Christ's body and the face of the Madonna immediately showed that Venusti did not start from the anatomical structure, which was completely absent from the drawing, but from an already finished chiaroscuro effect. The Madonna's mouth and the hollows of her eyes were already shaded, which

rendered her profile hard to make out. Christ's torso showed no sign of ribs or abdominal muscles; instead, broad watery strokes presaged the shadows they cast in the final painting. The same was true of Christ's left knee. It was roughly outlined with brushstrokes along the shadows created by the kneecap, but its bony structure was not actually traced.

Exactly the opposite was true of the American reflectogram. There the artist had produced a perfect anatomical sketch of the figures. If it had been possible to separate the drawing from its pictorial layers, it would have been identical to the numerous surviving sketches made by Michelangelo for the last figures from the *Last Judgement*. The way the ribcage is attached to the sternum provides the skeletal structure on which Michelangelo then painted the musculature, which in turn produced the shadows. This is typical of his painting method. You can count the bands of abdominal muscle and see the mass of muscle in the left leg. Moreover, the line with which the artist joins the pouncing dots after transferring the drawing is as sharp as if it were drawn with a pencil, using a fluent but crisp style. Only on the cherub's head ornamenting the Madonna's brooch does the brush widen, and it does so with sufficient expressive force to suggest an impromptu hand-drawn sketch.

The first striking result of the reflectogram of the Borghese *Pietà* was to rule out that the two panels had been painted by the same artist. The second was to prove that the artist who painted the Ragusa panel created the painting from a confident anatomical basis: indeed, while Venusti did not understand the anatomy of the figures and tried to evade this problem by simply reinstating the chiaroscural contrast in his copy, the Ragusa artist used the underdrawing to transfer the anatomical structure, both in outline and in detail, depicting the kneecap, the leg muscles, the way the ribcage was attached,

and even the shape of the breastbone. This relationship between the information transferred in the underdrawing and the final painting was the same one that Michelangelo used in his frescos, for which even his engravings are significant and complete images in their own right, albeit lacking colour.

In short, the underdrawing for the Ragusa *Pietà* was an entirely separate drawing, one that could stand on its own. In contrast, the underdrawing for the Borghese *Pietà* (and this was also true of the *Crucifixions* in the Doria Pamphilj collection in Rome and in the Casa Buonarroti in Florence) was only the memory of a painting reproduced in chiaroscuro, in which the shadows are given much more weight than the actual structure of the body. This also provides the 'technical' explanation for why Venusti's figures have no depth, no structure, and why the Borghese painting, when seen in real life, is inconsistent to the point of being grotesque.

All this was confirmed over the following weeks, as the tests were carried out on the *Crucifixions*. The Doria painting was very close in terms of *ductus* to the Borghese *Pietà*. The brushstroke joining the pouncing dots was often watery, and the start and end point of the stroke were clearly visible. That the anatomical framework was recreated by using sweeping areas of shade was evident in Christ's torso and in his left kneecap. There is no trace of the bones or muscles, but instead broad chiaroscural brushstrokes conjure up the structure. Although the layout of the Florentine *Crucifixion* appears to be identical, the graphics of the drawing are very different. The lines are more confident and thinner. They give a clearer definition of the areas of colour, and of light and shade. In the Doria underdrawing and in that from the Casa Buonarroti, the profile of the torso could hardly be more different; but this is much less visible in the finished painting.

By the time the tests on the two Italian *Crucifixions* had

been completed, it was apparent that the differences in hand and execution technique were too great for them to be by the same painter. The figures of the Virgin and of St John are positioned at different heights compared to Christ: higher in the Doria painting, and lower in the copy from Florence. This fact alone, which did not require any infrared reflectography but merely a careful observation of the two paintings in real life, completely undermines the legend that Venusti composed these crucifixion scenes using a collage of various drawings by Michelangelo – namely that he would have copied the Christ from the *Crucifixion* now in the British Museum, and the figures on either side of the Cross from the two studies in the Louvre.

Although bizarre, this theory can again be explained by the need to back up Vasari's anecdote that Michelangelo left no paintings, only drawings, and that, acting independently, Venusti turned these drawings into paintings. If this were true, Venusti would have created a *cartonetto* [cartoon] from Michelangelo's drawings – a sheet of paper containing the general design to be transferred onto the panel. The cartoon would have contained all five figures: the crucified Christ with the grieving angels and the two figures of the Virgin and St John. Once these figures were assembled on the cartoon, their proportions would have remained unchanged; yet this is clearly not the case in the two paintings.

The divergence of the underdrawings only confirms what can be surmised by observing and measuring the paintings. Moreover, it reaffirms what was already apparent, even if only on stylistic grounds. Not only does Marcello Venusti have a fluid, vague style of painting that tends to negate the internal spatial quality of the figures and to dissolve the sharpness of their contours, but he also has an idiosyncratic way of rounding the fingers and truncating and splaying the last two toes,

in what can be best described as an artistic tic. This stylistic quirk can be seen in all Venusti's signed works.

Rome boasts as many as six paintings which are undisputedly by Venusti: in addition to the *Pietà*, these comprise the *Madonna and Child*, also in Galleria Borghese, a *Noli me tangere* at Santa Maria sopra Minerva, an *Annunciation* in the sacristy at San Giovanni in Laterano, and two small paintings – again, on Michelangelesque themes – the *Sacra famiglia* and the *Annunciation*, in Galleria Corsini. So there is no lack of material for comparison; and, above all, the paintings can be compared physically within a very short space of time. Those stub toes, which make the feet of the Madonna and St John look deformed in the Doria *Crucifixion*, are particularly striking. They are a 'workshop trademark' to be taken into account.

The real surprise was that the tests on the Florentine painting revealed an underdrawing of superior quality to the one of the painting in the Doria Pamphilj collection. The next stage was to compare these results with the third painting, in Oxford. The Oxford *Crucifixion*, a painting rarely discussed by art historians, differs to an even greater extent from the other two. Although it is of excellent quality compared to the two Italian copies, it too has been cloaked in invisibility – an effect of the prejudice of its attribution to the diligent artistry of the copyist Venusti. Indeed the only art historian to study the painting dismissed it on these grounds in two short pages in the Burlington Magazine in 1961. Yet the Oxford *Crucifixion* has a history that certainly deserves closer attention. On the back of the panel are as many as eight seals belonging to the Cavalieri family. An inscription, again on the back of the panel, states that it was painted by Michelangelo for his friend Tommaso Cavalieri and remained in the family until it was purchased in 1797 by the English consul, who shortly afterwards took it to England.

The *Crucifixion* belonging to the Cavalieri family was then sold at auction in 1807, along with other works by Titian and Rembrandt. It achieved the highest price in the sale, a sign that nineteenth-century connoisseurs, who were used to dealing with paintings, not photographs, were well aware of the difference in quality between the painting for Michelangelo's beloved Cavalieri and Venusti's replicas. Once again, the painting remained 'invisible' for the next one hundred and fifty years, because Vittoria Colonna's letters, which praise a painted *Crucifixion*, have been overshadowed by Vasari's account.

I felt it was essential to analyse this painting, because Vittoria's letters linked the two works together. Moreover, any resemblance in terms of materials, pigments, underdrawings, preparation, or the multitude of other aspects you can read in a painting would be extraordinarily important, given that Michelangelo did not produce a large number of panel paintings. A detailed analysis of the Oxford *Crucifixion* was vital to my hypothesis, which was based on the existence of at least two panel paintings by Michelangelo referred to in the letters. So we went to Oxford after finishing the tests in Italy, on the grounds that the results we had obtained more readily from the Italian museums would make comparisons with a third exemplar easier, an assumption in which we were proved right. However, before flying to Oxford, it was important to visit Dubrovnik, to look for traces of Tempestivo and Crisostomo Calvini.

The city which, for centuries, had seemed so close and yet so far from the Adriatic coastline had vanished altogether during the years of communist regime under Tito. For decades there had been an impassable curtain only a few nautical miles east of Ancona. Now, after a horrible war, which was close enough to be even heard and seen from Italy, Dubrovnik

had returned to the West, and travelling there was relatively easy. Yet, in my imagination, that city, which had been closed for years to European visitors, was still shrouded in mystery. This was the only reason I can find to explain why it took me so long to cross the one hundred and eighty nautical miles that separate Bari from the renowned harbour of Dubrovnik.

15

THE STONE CITY

On this occasion, physical distance certainly turned out to be a variable linked to cultural and political distance. Nor was this just my impressionable imagination. In May 2009, twenty years after the collapse of the communist regime that had imprisoned Yugoslavia, wiping out centuries of close cultural ties with Italy, there were still no direct flights from Rome or Bari, no regular ferries, not even a hydrofoil. To reach Dubrovnik we had to fly to Vienna and wait several hours before taking another flight to the Dalmatian city. Dubrovnik finally appeared below us, at the end of a very steep, high ridge that rises above it to the east, protecting it and making it almost inaccessible from the land. The old city was entirely surrounded by a massive double wall, cutting itself off from the land and turning its back on the sea.

The taxi left us at the eastern entrance, in front of the old port with its double arched entrance. The city looked entrancing, clean and light, its air full of honey-scented blossom. It

reminded me of Rhodes; indeed, for centuries these two impregnable fortresses defended the route to the Holy Land. But the colours are less brilliant: the bougainvillea and prickly pears of Rhodes are replaced here by myrtle and cypress, a clear sign of the more northern latitude. Also Dubrovnik is more authentic than Rhodes, the latter being the rebuilt fascist image of an ancient holy city.

A downward sloping street, polished clean and slippery where the stone was worn away, led us through the double gateway and then along a narrow passageway straight into the main square. This is the hub of the entire city. The square next to the eastern gate is linked by a street as straight as a die to the west gate just visible between the very high walls on the other side of the city. Identical palaces line both sides of the street. Only at the start of an unusually wide space could you see some more complex palaces, medieval and almost Venetian in style due to their monumental triple lancet windows in stone. This irregularly shaped open area is dominated by the rector's palace, the cathedral, and the bishop's palace. A cluster of stone houses with less clearly defined structures climbs up towards the southern walls, which guarded the city against the sea and invaders.

It was an architect's dream, and Marina and I walked down the paved streets, grinning idiotically and pulling our noisy trolley bags. There was no space for gardens or parks. Life and possessions here were closely guarded, and the merchants had expected the utmost collaboration from their architects. The clarity of this layout presaged Manhattan: in every situation where merchants have the upper hand, the outcome is always one of brutal geometry.

In 1667 an earthquake destroyed most of the old city. This provided an opportunity to rebuild a city with a unified design, one that was extremely elegant but stern. To do so,

the republic chose the most decorous and least ornate from the Italian proposals. To judge from the results, the city might well have been designed by the fifteenth-century artist who painted the Urbino panels showing views of an ideal city. Many now attribute these to Bramante, but for years they were believed to be by a Dalmatian architect, Luciano Laurana, who built much of the Ducal Palace at Urbino. The urban design is comprehensive, minimalist, and makes a virtue out of necessity. In the wide space close to the west gate, I glimpsed a giant pittosporum and an orange tree still bearing the previous year's fruit. Those trees alone would be enough to sweeten the air within the entire space of the city walls.

We decided to treat ourselves to a room in the only hotel of the old city centre, which was housed in an old aristocratic residence overlooking the market square. While the young woman at the reception desk mulled over my request for an out-of-season discount, Marina and I stood with our heads thrown back, staring at the ceiling. We were there to find Tempestivo's coat of arms; and on the ceiling there were arms belonging to the leading Ragusan families. We could hardly help staring. This was the beginning of the 'rewiring' that allowed us to spend three days not in twenty-first-century Dubrovnik, but in sixteenth-century Ragusa. I had experienced this sensation of time slip before, but never for so long or over such a wide space. On the other hand, I had never visited a place that had changed as little as had the city we had come to explore.

My hopes of finding significant traces of Crisostomo Calvini and Fabio Tempestivo in the city were not high, and I was prepared to embark on a random search. At the Vatican they had explained that all the sixteenth- and seventeenth-century documents on Ragusa (which should have found their

way into the Vatican Archives, like those from every other diocese) had been lost in the seventeenth-century earthquake. Many later documents had been either burnt by Napoleon or destroyed by the communists. For a historian, it was like sowing salt on the ruins of Shechem. But, buoyed up by my indefatigable optimism, I decided to test the waters, and before leaving Rome I had sent an ingenuous request for help to the central archives in Dubrovnik. I did so with the condescending scepticism with which the English used to address Italian government officials in the past. Two days later the reply arrived, written in much better English than my initial request. A copy of Fabio Tempestivo's will had been found in the municipal archive of the republic, which preserves a copy of every deed stipulated by the city notaries. But of Crisostomo Calvini there was unfortunately no trace. I was disappointed by the news, since I had hoped to find documents on Calvini proving that he had received the *Pietà* from Pole. As for Tempestivo, I was really only interested in finding another copy of his coat of arms, to confirm the one I already knew about – the one on the walls of Beccadelli's villa on Šipan, the island a few miles from Dubrovnik, where it had been photographed by Martin.

I had been brought to Ragusa by a combination of scientific scruple and irrational gut feeling: this was the place where the story had already twisted and turned at least a dozen times. My only definite appointment was at the State Archive, to see Tempestivo's will the following morning. The rest of our stay would be a treasure hunt: the aim was to find at least one example of Calvini's coat of arms, and another one of Tempestivo's. That way we would not have to go to Šipan. By the time we had successfully completed our negotiations over the hotel room it was barely mid afternoon. It would be light until late on this fine Mediterranean spring evening. We

immediately headed for the cathedral, less than a hundred metres down the street, where I was sure we would find the tombs of both archbishops, complete with stone plaques and arms. Inside, the floor was made of industrial marble and had been laid only a few decades earlier. There was not one tombstone in sight. In response to our insistent questioning, we were told that everything had been destroyed in the earthquake of 1667.

I decided not to waste another moment of our time and instead hurried to the bishop's palace, which stood in the same square. We identified it by its magnificent façade. Beccadelli and his architect must have been impressed by Giulio Romano's sense of irony and they had astounded these rich, provincial merchants of Ragusa with an incomparable show of elegance. The simple building was ornamented with majestic moulded windows and a massive angular *bugnato* [a type of rusticated stone coursing typical of the Renaissance]. A frieze with a continuous wave motif completed the fashionable ornamentation of the palace. But the doorway was barred, because the building was undergoing restoration. It was just after five, and almost everyone had left. An old workman was cleaning his tools before tidying them away. Not wishing to take no for an answer, I persuaded him to let me into the building by telling him that I did the same job. The palace had been gutted, and not for the first time. There was no trace of any sixteenth- or seventeenth-century decorations. This, too, was a dead end. The salt sprinkled over these ruins had clearly killed all the seeds of memory.

Looking at the guide, Marina had identified the two largest churches inside the old city: one had belonged to the Dominicans (indeed it had been recently given back to them), the other to the Franciscans. Neither order had ever had to come to terms with the communist interpretation of history.

Under that regime the external decoration of these historical monuments had been left intact, but every trace of functional continuity had been eliminated, a process that reduced these monuments to mere shells, abstract vehicles of mere aesthetic content. The act of worship and all its related objects had been purged from the churches together with the priests. In the Dominican church, stripped as it was of its decorations and of the antique floor, there were two altars with coats of arms. Neither was of any interest. We spoke to the parish priest and asked him whether he thought that Archbishop Calvini, a Benedictine monk, might have been buried outside the cathedral. He pointed out a church, on the other side of the bay and beyond the Soviet-style package-holiday hotels.

Luckily the May evenings were now quite light, and at half past seven a taxi dropped us off at the start of the path leading to the old church founded by the Benedictines. We could hear psalms being sung as we walked up to it; at least it would be open. Open yes, but completely bare: as dreary and grey as a station waiting-room. The only light came from the crucifix placed over a single altar made from a butcher's marble slab. A group of women were telling their rosaries in Croatian.

I struggled to contain my disappointment. I had come to know Ragusa through the eyes of the apostolic visitor in 1573. I had followed him into every church and observed every altar, chalice and candelabrum; I had even admired the table-cloths embroidered in silk and gold thread that were used in the refectories of the churches looked after by nuns. I had seen the broken steps, the glass windows blocked with jute, and the musical organs with their gilded frames, donated by rich cloth-merchants. On arriving in the city, which at first sight had seemed so well preserved, I had fooled myself into believing that everything would be the same. Instead, it had all disappeared. The city's tormented history, the countless

changes of government and policy had deleted all trace of memory. It was as if the relief had been sawn off an old marble plaque, turning it into a smoothly polished slab in which you could see your own reflection, but nothing else. Even the cemetery failed to produce anything. There were very few coats of arms. Everything had been removed or defaced. The odd decorative feature had survived on doorways or under a window, but nothing that interested us. The first day in Dubrovnik ended rather disconsolately.

Like every other Mediterranean destination, the city was getting ready to welcome the summer tourists. The streets were lined with countless cafés selling ice cream and with hundreds of souvenir shops. There was no shortage of the typical consumerism found in every Mediterranean seaside resort. Spain, Italy, Greece and, as I now discovered, Croatia offer an identical range of fast-food chains and bars advertising happy hours, where teenagers can head off at sunset, on the start of a drinking binge. The proliferation of these commercial outlets, so completely devoid of any local colour, has finished off the job that communism had started. Nothing remains of the Catholic, then Italian, Orthodox, and finally Austro-Hungarian identity of Dubrovnik. I also wondered how communism itself could have disappeared without trace, only a few years ago. Perhaps all that is now left are the sombre and melancholic faces of those middle-aged men and women whose bodies have not yet been overwhelmed by the intoxication of consumerism and by the assault of brand names – which have so radically transformed the rest of Europe. Only early the following morning did a minute part of that lost world reappear, in the marketplace below the windows of our pretentious Hôtel de Charme.

We had been warned that the square doubled as a farmers' market in the mornings, and I had wondered where they

would put their stalls, given that the cafés and restaurants filled most of the space with their tables. I was woken at daybreak by muffled sounds from outside and, curious to see what was happening, I opened the window. Two men were arranging simple wooden planks on green trestles, in perfectly symmetrical lines. Half the square was covered by tables. They worked in complete silence. When we left the hotel, I thought we would find the stalls laden with the same copious quantities of produce I see in the local market I walk through every morning, in the centre of Rome. Instead we were amazed at first, then fascinated by the sobriety of the goods on offer here and by the dignified simplicity of the sellers. Most were peasant farmers, their faces weather-beaten by the sun. They had been here since dawn, setting out their vegetable produce on the green painted planks: a few bunches of dirty carrots, enough vegetables to feed a family, no more; a handful of apples, or two jars of honey. A flower stall seemed to me emblematic of this market because, perhaps spontaneously and unwittingly, its display made up for the limited monetary value of the goods by exalting their poetic beauty.

16

TEMPESTIVO'S FUNERAL

The archive, which overlooks the cathedral square, is housed in a fourteenth-century palace decorated with huge stone mullioned windows with three lights reminiscent of the Doge's Palace in Venice. The inner courtyard is surrounded by a wide portico of squat stone columns. That morning the cool night air seemed to linger over the moss-covered paving stones, and the carvings and profile of the arches made me feel at home. It was a strange sensation to find myself listening to a language so incomprehensible, so foreign to my own phonetic patterns, yet to be surrounded by such familiar architecture. It was as if I had returned home after a long journey to find Italy occupied by people from a far-off land.

The archive staff were leaning against the balustrade, enjoying their coffee and cigarettes. There was still a quarter of an hour to go before opening time, and we felt duly mortified. We turned to go, but a woman in a white coat called us back and invited us to take a seat in the reading room, where

the sun was streaming through the three-light mullioned window onto the old wooden reading desks. I introduced myself and showed her the email correspondence. Dr Ivana had already guessed who I was, and a few moments later a grey-coated assistant appeared, holding the folder that contained Tempestivo's will. Marina sat beside me and started to leaf through the catalogues, in the hope of finding something that might lead us to Crisostomo Calvini. Dr Ivana had been quite firm. There were no documents relating to the archdiocesan curia in this archive. If anything had escaped destruction, then I would find it in the Curia itself, on the other side of the city.

As I looked through the documents I had that odd sense of familiarity again, because they were all in Italian – a language that no one here could read. Tempestivo's will was written in beautiful copperplate script, and I started to transcribe it onto my laptop.

Likewise [*item*], I command that a notarial deed be drawn up of all the large furniture and wooden items, both in Ragusa and in Giuppana [Šipan] or elsewhere, including casks, large and small vats, barrels, tables, small tables, chairs, bedsteads, ironware and similar things, and that they be deposited in the Chapter House of the cathedral, which promises to preserve them and give them to my successor.

Likewise, let a public deed be drawn up immediately after my death by my executors and certified by the Chancellor or another notary, listing all my belongings, including all kinds of books, silverware and gold, both in coins and otherwise, clothing, bed canopies, mattresses, blankets, sheets, linen for the bedroom and the table, wines, cereals and other fruit, and every other remaining object, and let them be distributed as detailed below:

I leave to my metropolitan church my Pontifical and liturgical manual, which I desire should be kept by the procurators to be used as necessary, but not for daily use in prayers for the dead, or the like, otherwise they will become worn too soon, thereby depriving the church of their use. Likewise, I leave my mitre and its box to the said procurators.

Likewise, I leave to the collegiate church of St Bartholomew, the Apostle of Montefalco, my pluvial, made from silver cloth with gold trimmings and silver rings, and a red damask chasuble with a stole and maniple with gold trimmings; my family arms are on both.

Likewise, I leave to the reverend nuns of the poor convent of Holy Mary Magdalene, of the said land, my white damask chasuble with stole and maniple and gold trimmings, and I leave my gilded Crucifix with the cross and ebony stand to Sister Agnese, my niece, for the rest of her life, so that she may have occasion to reflect herself constantly in it and remove any stain and embellish her soul with virtue, making it more pleasing to her husband Christ our Lord.

Likewise, I leave to the nuns of the Convent of the Blessed Chiara, in the said town, my small gold pectoral cross full of Holy relics, and also a fragment of wood from the Holy Cross, which I wish to be kept in the box where the body of Blessed Chiara rests. Likewise, I leave for the use of Sister Clarice, my niece in the said convent, the small painting of San Carlo, in a silver frame with gilded corners.

Likewise, I leave to the poor nuns of the Convent of San Clemente, of the said land, my chalice with the silver paten and pouches, the two chasubles of green and purple silk dupletta with their stoles and maniple, with trimmings and silk fringes.

Likewise, I leave to Don Bernardino Zuccari of Montefalco, my faithful old servant and now Master of the

Household, sixty ducati di grossettino, ut. D.ti 60; likewise I leave him my black tunic made from Sienese cloth, the Somma corona vulgare in three volumes, one of the two golden candelabra, namely the embossed one; the small Bible in octavo, and my large missal.

And I ask my heirs that, should Don Bernardino wish to stay in our house in Montefalco or in the house next to the kitchen garden, he should be given the lodging for the rest of his life; and, should he wish to serve in the house, in keeping with his status, he should be offered board.

Likewise, I leave to Don Doroteo Bonomo of Ripatrasone, my chaplain, thirty ducati di grossetti; likewise my cassock of black Milanese serge to the same, and the book De imitatione Christi.

Likewise, I wish that any other Italian servants in my service be given five ducats in addition to their salaries.

[. . .] When I was promoted to this archbishopric, the most Illustrious Republic of Ragusa was informed that the Archbishop's church and house on the island of Giuppana were at risk of collapsing and the vineyards were badly kept and many had become infertile, and it therefore granted me one thousand ducats to spend on repairs and improvements. These works have been carried out and are still in progress; but I undertook that, after six years, I and my successors would repay a set sum every year, as agreed in the deed drawn up under licence from the Apostolic See. Yet, although some payments have fallen due, the Republic has never made any request, and perhaps they never will because of their usual benevolence. However, it is my intention to repay them whenever they demand it and to the extent that I can afford it, given the meagre nature of my income. At present, I leave this Republic all the livelli or rents that have accrued to this Archbishopric at the time of my death, and are

consequently my property and shall not be collected. If the said rents amount to more than the debt owing at that time to the Republic, I hereby bequeath the excess to the Republic as a free gift, since I trust that, given its holy piety, should it not suffice, it will not seek more. If necessary, it shall take action against future archbishops and against the archdiocesal properties, which have been improved and are more profitable.

In order to meet the expenses of my exequies, the expenses to be paid to members of my household for the time spent in the house, and to pay any debts, including the legacies made in this Codicil, the salaries owed to servants and money owed to any creditors, if there is not sufficient cash, then the movable assets shall be sold: first the grain, wine and other fruits, then personal woollen clothing, silk and linen garments and any other linen, not including the things disposed of individually in this Codicil, up to the sum required to pay the aforesaid debts and legacies. All my other movables and goods, I leave to my heir Girolamo Tempestivo, or, in his absence, to his sons.

My executors shall write to Signor Girolamo immediately after my death, using duplicate av[v]isi sent by Ancona and Venice, informing him of the manner of my death and sending him a copy of the inventory of my gold and silver and all my other possessions at the time, and a copy of this Codicil. He shall advise the executors of his intentions and whether he wants them to sell some objects here, and which ones, or whether he wants them to be sent to Italy. He shall not suffer any affront to the authorities in Ragusa by the Commissioners, over spoils they do not possess or over the goods left by archbishops, and, depending on the instructions he gives, they shall implement them either by selling the goods or by sending them via Ancona.

[. . .] as the true executors of my last will and testament, I appoint and beseech you to accept this burden, most Illustrious and most Reverend Signor Pietro Benessa, canon of this metropolitan church, and most Illustrious Tomaso Gondola, as well as the Ragusan aristocrats Signore Pietro Pallicucchia from the Isola di mezzo, and Messrs D. Bernardo and D. Doroteo, granting them the necessary all-encompassing powers to [. . .] account for all my stuff and send it to Italy, subject to the instructions of my heir, and D. Bernardo shall do everything with the advice and help of the other executors [. . .] I hereby make these my last wishes which I declare shall be valid subject to the law [. . .] written in my own hand and sealed with my family seal in Ragusa on the first day of January 1516.

At first I did not understand the importance of this testament. I continued to copy the entire text onto my laptop, almost without thinking (although I subsequently I discovered that I could have photocopied it). As the details of Tempestivo's life and possessions appeared before my eyes, I remained strangely indifferent, because in my heart of hearts I was convinced that the key to the whole affair lay with the protagonists of the thirty-year period before Tempestivo. How wrong I was!

As I transcribed the will, I was amazed at the wealth of detail contained in the document, details that revealed the man's personality, his devotion to San Carlo Borromeo, his superstitious veneration for relics (he even thought he owned fragments of the Holy Cross). He reveals himself as the perfect populariser of the Tridentine Counter-Reformation, someone diametrically opposed to the generous *spirituali*, dreamers who had fought and lost a fierce battle against these superstitions. What would Pole, Michelangelo or Vittoria Colonna have thought of this man, who preserved rotten

fragments in the belief that they offered salvation? A man who instructed dozens of masses to ensure the redemption of his soul. Where was the true faith of Michelangelo and Vittoria? Where was the tortuous inner scrutiny that would unite him with Christ, who had given His life to save mankind? But Tempestivo's detailed will also cast light on his own belongings, and on his attachment to particular objects. However, there was no mention of the *Pietà* among his possessions. Tempestivo did not own the painting, despite the fact that he had set his seal on it. I had always been sure of this, but the document in Dubrovnik confirmed it without a shadow of doubt.

This list made it clear that the *Pietà* did not belong to him; therefore he could not leave it to his nephew or nieces. If it had, the *Pietà* would have appeared beside the small painting of San Carlo Borromeo. The archbishop's seal was added on his instructions when an inventory was drawn up of the archbishopric's possessions, which were partly to be stored in the cathedral until his successor arrived and partly to be sold in order to pay the archbishopric's debts and the costs of his solemn funeral. Once the money and gold had been safely put aside, together with the family possessions to send to his nephew in Italy and to his nieces in the various convents, the property of the archbishopric (furniture and furnishings, grain and other provisions) would be sold to raise the money required to pay off the debts and ceremonial expenses. This, at least, was the understanding of a devout Counter-Reformation bishop like Tempestivo, subject as he was to the strict control of the republic's magistrates, who in any case would not have allowed him to break the law. But there was another vital piece of information waiting to be revealed at the foot of the will – although I had not yet realised this when I suggested that we should stop for lunch in one of the

quayside cafés and try out the octopus salad served with vinaigrette and sliced onions, which had been heartily recommended by several friends.

When we returned to the reading room, we were amazed to find that none of the staff had left; yet, in spite of there being no afternoon shift, they continued to be exceptionally kind and thoughtful. I went back to the manuscript and found the records of payments that had been added at the bottom of the will over time. In this case the precision of the Ragusan magistrates had preserved a crucial link. The city courts made a practice of recording a copy of every private deed stipulated in Ragusa, and they ensured that the testamentary wishes were executed under the authority of the 'executors' appointed by the testator. The beneficiaries or creditors then had to provide a receipt that was annotated on the will. There was one that explained a lot of things.

> On 22 October 1616 the Reverend presbyter Nicola Petri, who acted as priest at the funeral [. . .] confessed and declared of his own accord that one hundred and fifty-three ducats were spent on his instructions for the said funeral, of which thirty-seven were paid by the Reverend presbyter Bernardino Zuccari, one of the executors, and also included the eighty-seven ducati grossi received from the hands of Simone di Giovanni Gozze and partners.

The faithful Bernardino had sold many of the archbishopric's possessions, as Tempestivo had instructed, to a certain Simone di Giovanni Gozze. This was none other than the ancestor of the unfortunate Countess Nicoletta Gozze, who had fallen in love with the young Consul Von Lichtenberg. It was in her house that Michelangelo's painting was eventually seen for the first time in 1840, two hundred and twenty years after

Tempestivo's death and after the sale of many of the arch-
bishopric's possessions. During all that time it had never left
that drawing-room. The hereditary line, which Marina had
started to reconstruct by tracing the various changes of own-
ership, led straight to Nicoletta's husband; but the impor-
tance of this finding had already been overshadowed. Instead,
although I had previously underestimated it, the will had
turned out to be an extraordinary source of information.
Tempestivo had found the painting in the archbishopric,
where it had been left by Crisostomo Calvini or, less likely, by
Ludovico Beccadelli. Following Tempestivo's death, his pri-
vate possessions had been scrupulously set aside, and the
painting had been sold, together with other goods, to pay off
the church's debts. The buyer had been a merchant, Gozze,
who then left the painting to his successors. The discovery
was as sensational as the one I had made in the Vatican
Archives – except that here, outside the archive in Dubrovnik,
there was no chaotic Roman traffic to bring us back to the
hurly-burly of the twenty-first century.

The perfumed dusk that enveloped us as we left the build-
ing made the city seem even more fantastical, as if time had
stayed still. The hours spent in the company of people who
had lived, loved and suffered in those narrow streets, worn
smooth by their steps, left us with the strange sensation of
having travelled back in time with one of those machines that
work so well in films. It would not have surprised us to meet
old Crisostomo, tired and haunted, as he dragged his feet to a
church door. Or even to catch the Apostolic visitor, eaves-
dropping from the windows of the archbishop's palace as he
tried to overhear an unguarded conversation in the square we
were sitting in. Or to see an elegant merchant returning
home, satisfied with the deal he had struck; or Tempestivo
himself, in a procession, wearing dazzling liturgical vestments

to remind the senators of the republic of his status as the representative of an even greater power. Or even poor Nicoletta Gozze, whose melancholic gaze followed the handsome Baron Von Lichtenberg as he flaunted his Austro-Hungarian uniform on the Corso and spoke condescendingly to the local notables, whose own fates were sealed by their declining political influence. Dubrovnik had not only provided another important clue in the story, it had also taken us on a journey back in time, an experience so fascinating that, for a while, Marina even forgot her nostalgia for the children we had left behind at home, in Rome.

17

THE ISLAND OF ŠIPAN

Tempestivo's seal, which I expected to be the easiest quarry of the trip to Dubrovnik, proved elusive. I had imagined that his arms would be displayed in the cathedral, in the archbishop's palace, on commemorative plaques; yet there was absolutely no sign of his arms – or of any other bishop's, for that matter. So we decided to go to Giuppana (the island known today as Šipan) to find the plaque that Martin had photographed during his visit (or so I had assumed). After spending the morning in the archive, leafing through wills and photographing wax seals, we spent a small fortune on hiring a fast rib owned by two Croatian lads, who revved the powerful outboard engines as they waited for tourists to arrive.

We skimmed across the calm sea, protected by the numerous islands in the gulf, and barely forty minutes later we landed at the small port on Šipan, a tiny island with a population of under one hundred. This was the island where Beccadelli had chosen to build himself a leisure villa to escape

the summer heat. He was not alone in this: other leading families had also built here splendid residences overlooking the sea. We were welcomed by the medieval tower of Palazzo Scoccibuca, the family whom many suspected of having bought the painting from Beccadelli. The luxuriant island seemed almost uninhabited, but our skippers spoke to the owners of the bar on the quay, who were sitting outside smoking while they waited for summer visitors, and a quarter of an hour later Maria arrived. This was the young guide who would drive us up to the villa. She, too, seemed to belong to another world, like the peasant farmers in the market that morning. Gentle and shy, she was embarrassed by her halting Italian and seemed overly concerned that she would not be able to help us. She stopped to show us an old medieval church, which had also been stripped bare and was falling to pieces. Then we left the car on the roadside and made our way up a path through a dense wood of alders and chestnuts whose branches were covered with shiny new growth.

After walking for a few minutes we reached the villa. It was in ruins and almost entirely overgrown. The real danger of falling masonry made access impossible. Maria looked downcast at the sight of our disappointed faces, and I now understood why she had looked puzzled on the quayside when we explained the reason for our lightning trip to Šipan. She had known straight away we would be disappointed. I showed her the photo of the plaque, but she had never seen it. Beccadelli's coat of arms was elegantly framed above the central doorway, but of Tempestivo's there was no sign. I could think of no obvious explanation.

We started to force our way through the tangle of undergrowth, ripping entire creepers from the walls. To start with, the idea of this Indiana Jones-style venture made us laugh, but after half an hour of frustrating attempts to find the plaque I

began to panic. Marina tried in vain to stop me from climbing into the precarious building through a window, and Maria offered to go first. I begged her to let me go alone, but Maria insisted that, without her help, it would be far too dangerous. It was an awful situation. She felt so ashamed of the decrepit state of the villa, as if she were personally responsible for having reduced it to a heap of stones on the verge of collapse. I took a few steps inside, hoping to catch sight of the frescos that Beccadelli had praised so highly. There was nothing. For decades, the villa had been used to shelter livestock. The communists had vented their rage against the Church's oppression by destroying Croatia's sole example of a Renaissance villa. We climbed out again. At all events, the photo I had showed clearly that the plaque was outside. I felt a renewed wave of panic. This plaque was crucial to my reconstruction of a key part of the story, and now it had disappeared. It was symptomatic of the fragility of history and historical evidence that a stone plaque could simply vanish.

Maria was visibly upset, and I tried to conceal my disappointment in order not to add to her unwarranted chagrin. At one point I stared down at my leg and brushed off a small red spider whose bite, Maria said, could be very irritating. I had no copy of Tempestivo's coat of arms to compare with the seal on the back of the painting. Moreover, if, for some inexplicable reason, I was mistaken about the three flames with the stars, and if the arms proved not to have belonged to Tempestivo at all, then it would be quite logical for the painting not to be listed among his personal property. And in that case, the record of a sale made to the Gozze family was merely coincidental. Marina took control of the situation. 'Thanks to the will, we now know that Tempestivo came from Montefalco', she reminded me. 'There'll be dozens of coats of arms in Montefalco. Remember the stoles embroidered with

his arms, and the chalices and chasuble. They are all there. It says so in the will. We'll find plenty of coats of arms as soon as we're back in Italy. After all, Montefalco is only an hour's drive from our house in the country.'

This was all true; but why had my internet searches not proved more fruitful? The explanation arrived the next day, as soon as we were back home. Marina sat down at the computer and typed in 'Tempestivo – Montefalco'. Dozens of sites came up on the screen. As I lay dejected on the bed, my wife came into the room waving a colour printout of the coat of arms belonging to the Tempestivi di Montefalco: three flames crowned by three stars.

'So, it really does exist. But why didn't we find it six months ago?' I exclaimed.

'When we searched on the web six months ago, you made me look for Tempestivo. That's why nothing came up. We should have tried using Tempestivi, then we'd have found the seal straight away.'*

While she unpacked, I was stunned by the thought of how the significance of every lead in historical research could be so transient. It had taken six months to find something that was only an hour's drive away.

* [Translator's Note: The plural form of the surname *Tempestivi* may initially have been used to refer to the lineage, the family as a whole; later it then became also the accepted singular form. However, even in the seventeenth century, Bishop Tempestivi was still frequently referred to as Fabio *Tempestivo* (hence the Latin inscription in Martin's folder, which calls him 'Tempestivus' and not 'Tempestivis'.]

18

OXFORD

The initial visit to Oxford took the form of a weekend break during which Marina and I met up with my sister Maria and her husband Sebastian, both of whom live in Amsterdam. My sister has worked for years on a philological study of Michelangelo's small paintings, and generally on the links among Buonarroti's artistic works in the latter part of his life, the years of his religious passion. She teaches history of art at Salerno University and has worked on Michelangelo for the past eleven years at least. She is my double, and this has helped both of us to share the burden of a research that would have been impossible to attempt by oneself. From the outset, we opted for a natural division of roles and tasks. My research methods are dictated by my constant dealings with the works of art themselves, and, at the other extreme, by a passion for philological accuracy that takes me into the archives. This is something that Maria finds more difficult: her life is busy enough commuting between Amsterdam and Salerno and

caring for two young children, as well as for our elderly parents.

This collaboration has been made possible by our shared passion and, of course, by our deep affection for one another. When I get back from a session in the archives, I often send her my transcripts, so that she can enjoy them with the same intensity as if she had been to the archives herself. In return, her systematic approach and her knowledge of languages, including German, Dutch and French – which I am useless at – mean that she can easily check any details in the scientific literature that would otherwise take me ages, robbing precious time from my work as a restorer. Over the years, it has not always proved simple to separate our roles and thoughts. Indeed, working in such close contact, we inevitably end up believing that ideas and thoughts suggested by the other were in fact our own. But the advantage is that our deep affection helps to resolve the inevitable clashes. My sister spent a few years working on a critical reorganisation of the whole question of the paintings, and she established the provenance of many of them by analysing the museum inventories. It was through her catalogue of Venusti's works that she managed, not without some difficulty, to trace the third *Crucifixion* to Oxford, where – again by happy coincidence – the library also houses the valuable series of letters written by Alvise Priuli in London to Beccadelli in Ragusa.

So we arranged to meet in Oxford. None of us had ever been there before, but it was just as we had imagined: green, old and terribly posh. Campion Hall, a small Catholic college, had given us permission to look at the *Crucifixion*, which had once belonged to Tommaso Cavalieri. Our guide was an elderly priest. Although in poor health, he still spoke perfect Italian as he led us into a bright room where the small panel had been brought for us to examine. The light streamed

through the bow window filtered by a Virginia creeper, which was redder than any I had ever seen. Its leaves, which lit up the grey stone wall of a projecting tower embellished with neo-Gothic mouldings, quivered in an autumn breeze that was extraordinarily mild for the time of year, or so our guide told us.

Unlike the Italian paintings, this small panel also consisted of a single wooden board, and the wax seals displaying the Cavalieri family arms were clearly visible around the edges. This repeated display seemed to reflect an obsessive need to assert ownership, a need that far exceeded the bounds of reason. It was immediately clear that the figure of Christ was in a wholly different league compared to the Italian copies. The modelling was stronger, and the painting and facial expression had a clarity that created the impression of an artist of much greater standing. The quality of the painting was so evident that it was embarrassing to think a whole generation of art historians could have believed this was the work of the same artist as the Doria *Crucifixion* and the painting in Casa Buonarroti.

Compared to the Italian copies, there were very slight differences in the iconography. The landscape was more sober, and there was less emphasis on devotional aspects: the haloes over the figures' heads were merely hinted at, whereas the sky was lit by the final moments of the sunset, without the obtrusiveness of the blazing nimbus clouds in the Doria *Crucifixion* or the flaming rays in the Florentine one. The figure of the Madonna was much more credible, and in particular the two angels on either side of the cross were more beautiful and more substantial. The painting looked very clean, indeed cleaner than it should have. At some later stage it had been varnished, too thickly, with a gloss finish. This gave the composition a vaguely northern feel.

We had seen enough to exclude the possibility that Marcello Venusti had been the artist who painted this *Crucifixion* for Tommaso Cavalieri. We were convinced that no one but Michelangelo could have painted such a masterpiece. Now it was absolutely vital for us to convince the directors of ENEA to fund a trip to Oxford to carry out reflectography tests on the painting. This would give us a benchmark for comparison with the other two *Crucifixions*. Unfortunately, of all the tests, those in Oxford proved the most problematic ones. It was difficult to renew contact with the Master of Campion Hall, and in the meantime it was rumoured that the painting might be sold at Sotheby's. It was a tricky situation: on the one hand, it was too early to affirm a possible attribution to Michelangelo, but on the other we did not want the painting to change hands before we had a chance to examine it. I asked the college to let me know in advance of any sale and of the estimated value, but fortunately no news ever arrived.

Next July we were ready to leave for Oxford and analyse the painting using the portable equipment made available by ENEA, on the understanding that, while we were there, a local laboratory would provide any apparatus that could not be transported (it should also be said that they lived up to legendary English courtesy). Nowadays artistic research must also make allowances for anti-terrorism laws, and every piece of equipment loaded on a plane has to go through enormously complicated security procedures. However, we finally arrived, together with our sophisticated equipment, in the well-lit room where we had first seen the painting a few months earlier. This time the light, which had been our most precious ally on the previous occasion, was not on our side. It did not prove easy to black out the small parlour, in which an entire wall was filled by the beautiful bow window, framed by the now luxuriant creeper and its fleshy green leaves.

As we got on with the preparations, I succumbed to an anxiety that had been welling up for days, although I had refused to acknowledge it. In spite of its geographical distance from the American painting, the Oxford *Crucifixion* was closely linked to it and to the hypothesis of its attribution to Michelangelo. If the master had painted the *Pietà* for Vittoria, he had also painted the *Crucifixion* for Tommaso: Vittoria's testimony was valid for both paintings. Either that, or it was unfounded.

There was an underlying and inescapable truth to the complicated story that had taken over my life for the past two years. Hypotheses and documents undoubtedly play a significant role in the search for an autograph work, but the material quality of the work is without question pre-eminent. The Oxford *Crucifixion* had passed the stylistic test with brilliant results; indeed it was the best of the three. It remained to be seen whether these results would be confirmed by technology. By now I was perfectly acquainted with the underdrawing that Venusti had used. If the tests were to show a laboured, watery drawing under the painting that had belonged to Tommaso Cavalieri, one comparable to those that had emerged under the Borghese *Pietà* and the Doria *Crucifixion*, my conjectures would be dealt a crippling blow.

Before positioning the equipment, I had already checked that the figure of Christ and the angels corresponded to the drawing in the British Museum. The tracing I had made fitted perfectly over the painted Christ, something that had not happened for the two Italian works. This first reassuring finding buoyed my hopes, as I waited for the imaging to begin. I knew from experience that it would all be over in a matter of seconds – the time taken by the sophisticated camera, focused on the painting, to send the first image to the waiting screen. I almost had to use physical force to convince Franca and Ombretta to let me stand in front of the screen for the first

shot. I felt guilty, because I had never mentioned my hunch that the painting might be by Michelangelo to either of them – partly because I did not want to affect the extremely rigorous imaging procedure and partly because such a momentous suggestion might easily lead them to doubt my sanity. In the end, it was their response that placated my fears. When the first image appeared, I was so worked up I could not bear to look at it.

'Mamma mia, it's beautiful.' Ombretta was the first to voice her excitement. Franca, more controlled, joined her moments later. 'It's completely different from the Italian ones. Look at those marvellous angels.'

In the British Museum drawing, which is unanimously attributed to Michelangelo, the angels are unfinished and sketchily drawn; but here they were strikingly beautiful. They were drawn with such expressive force that their outline seemed to have been etched with confidence onto the panel. But, above all, they had been delineated in much greater detail than had subsequently been incorporated into the painted image. Soon after this, when the images of the Italian tests were displayed on the screen, it was easy to see that the two Italian paintings had only copied the parts that had actually been painted, and not those that had been omitted from the final version.

This detail alone was proof that the two Italian *Crucifixions* had been copied from the Oxford painting, the one that had belonged to Tommaso Cavalieri. The Italian copyists had only reproduced the visible part of Cavalieri's painting, unaware of the flourishes that the artist had drawn and then decided not to paint, a form of *pentimento* typically found during the executive phase of completing a work of art. In the British Museum drawing, the two angels are poorly defined and barely hinted at, as critics are unanimous in pointing out.

Instead, in the Oxford painting the underdrawing fills this lacuna by revealing a more refined and carefully detailed design. Moreover, the artist's hand is, once again, so confident and expressive that, even abstracted from the painting, the angels represent an extraordinary work of art. Christ's body also revealed an outline that was dazzling in its fluidity and, above all, provided only basic information about the body's positioning in space: by proceeding in this way, the artist reserved the possibility of sculpting the body by using shading during the painting phase.

All three of us had brought computers, and the elderly father had left us alone to work in the parlour. Franca and Ombretta would have preferred to have taken shots of all the details now, and to collate the results in Rome. But I longed to compare the tests straight away. We opened the three laptops on the floor and brought up the images of Christ's torso in all three paintings: the Doria *Crucifixion*, the one in Florence, and now the one here in Oxford. The shaded areas on Christ's torso in the Italian works corresponded perfectly with the painted shadows on the figure of Christ in the Oxford painting. This meant that the underdrawings of the two Italian paintings had been copied from the finished English painting. In turn, the English painting had never needed to reproduce any lines in the underdrawing to mark the anatomical shadows.

This did not amount to the definitive proof of a Michelangelo autograph, but the results of the infrared reflectography strongly backed the hypothesis that Michelangelo had played a very active role in painting the *Crucifixion* for Tommaso Cavalieri. I took the time to explore this comparison in depth before reluctantly leaving Franca and Ombretta to get on with their work. In any case, there was no way I could have stayed. I had been nursing a high temperature

since the morning, and by this time I was on the verge of collapse. The trip had proved excellent in terms of its scientific results, but once again I had failed to gain any degree of familiarity with English cooking. The effects I was suffering after having eaten a lamb pie, billed as staple fare in a traditional pub, proved that the horrendous reputation of English cuisine in Italy was still well deserved. I made my way back to the hotel, hoping that tomorrow I would feel strong enough to face the long bus journey to Gatwick and the interminable queues through security.

19

BACK TO BUFFALO

After the trip to Oxford I abandoned my study of Tommaso's *Crucifixion*. Its story was already summed up in those red seals and, more to the point, I did not have the energy to research this painting as well. Luckily, my sister continued to document the various steps that took the painting from the Cavalieri family house to a religious college in Oxford. Moreover, she also clarified the changes of ownership for the two Italian paintings, confirming that both came from Venusti's workshop. In all, there is a very strong likelihood, stronger than for any other attribution hypothesis put forward for Michelangelesque works in the past century, that the Cavalieri *Crucifixion* is an autograph by Michelangelo. But there is still insufficient evidence to support this hypothesis. The painting would have to be restored, and the varnish removed; this would permit analysis of the technique, the pigment composition, and much else besides. But my impression was that the owners of the painting, the governing

body of that religious college, were perplexed by the whole idea.

The previous Master, the reverend father who had welcomed us so kindly on our first visit, appeared to be in increasingly poor health when we last met. Owing to his age, or – as I like to think – because he had spent many years in Italy at the Gregorian University, he had a courteous way of talking to us, and, when we eventually said goodbye, he told me sadly that he was moving to a Jesuit college closer to the sea, in the hope that it would suit his health better. He was cataloguing his books with the help of an assistant; and I, too, felt rather melancholic, as I imagined him reliving the memories associated with each title before it was packed away, and then spending the rest of his days on a coastline, perpetually wreathed in damp fog.

The kind elderly priest had been curious to know more about these foreigners who were so preoccupied with a small panel painting, also because, during his stay in Rome, he had understood how important, and how present, art is in Italian life. His successor was a much more dynamic character and, when I was introduced to him before leaving, he looked up only for a moment from his desk. He was much younger, but also less interested in the whole story. It came well down his list of priorities for running the house and the college, and I got the impression that he was a sort of manager of clergymen. To start with, he did not even answer my requests for information. I also tried to contact the older Jesuit, but he seemed to have vanished into the sea mist and I never heard from him again. After this, this line of research took a downward turn, like the subterranean tributary of a river. What mattered was that the trip to England had produced the answer I needed and my hypothesis regarding the American painting was still intact.

There was now no reason to delay my return visit to Buffalo to clean the *Pietà*. This was the next step to take before presenting the painting to the international community of experts. Years of working as an art restorer had taught me how difficult it was for an expert to analyse a painting that has been altered by retouching and additions, and how difficult it was for anyone without material experience to distinguish the authentic parts of a painting from the alterations, even with the help of those formidable diagnostic images which – if you knew how to interpret them – immediately revealed the original condition of the painting and its extraordinary nature. Moreover, the suggested attribution was made even more complex by the uniqueness of the painting, which could not be placed alongside a body of work, in sequence with other paintings, as it would be in the case of any other artist.

My conviction that this was a Michelangelo autograph did not help; quite the opposite, it made the task more daunting. No restorer, however expert or however confident, could tackle the restoration of Leonardo da Vinci's *Mona Lisa* with the same peace of mind as he or she would take on the restoration of a panel by Ghirlandaio or Pinturicchio. I knew that the Ragusa *Pietà* was much more important than Leonardo's *Mona Lisa*. Not only because it is extremely rare to find movable works by Michelangelo – the catalogues list no more than three or four, at the most – but because the painting was the symbol of such an important historical episode that it superseded every other object produced during the Renaissance. When I thought of Vittoria Colonna crying her heart out in front of the small panel painting, or of Henry VIII's cousin, Reginald Pole, staring at the *Pietà* in exhaustion, during the sleepless nights before the great battles of the Council of Trent, my anxiety levels came very close to complete panic.

What was more, how would I manage in Buffalo, on the other side of the world, where I would have to transport (a problem not to be underrated) all the solvents and other restoration equipment? Having realised that this was a job I could not tackle alone, I started to hunt around for someone to help me. It would have to be another restorer, who would provide top-notch expertise – but also someone who could be more detached from the work. Moreover, this person would have to guarantee his or her utmost reliability, but at the same time be someone for whom restoration was routine work.

With some circumspection I began to cast around for a collaborator. The restoration of the Piccolomini altar had ended in late November. It had been successful, and everyone had appreciated the careful cleaning of Michelangelo's sculptures. In professional terms, I suppose I could think of myself as being at the height of a satisfying career; furthermore, my books had also been translated into the main European languages. But I could not escape from the fact that, in view of all this, a mistake or a false move in connection with the American painting would prove even more painful. To cap it all, immediately after I finished work on the Piccolomini altar, I was asked to restore Pinturicchio's large fresco on the external wall of the Piccolomini Library.

The job got off to a dreadful start. The panels on the interior walls of the library had that clarity, that calligraphic precision reminiscent of the great tradition of Italian fresco painting in the fourteenth century. But when Manuela Micangeli, who was working with me on the commission, and I tried to clean the fresco, we realised that it had been painted using fragile glazes applied *a secco*, which were extremely sensitive even to water. They could certainly not be touched by the solvents normally used to clean true fresco [*buon fresco*], such as the solution made from a low concentration of ammo-

nium bicarbonate. The cleaning needed in order to consolidate extensive areas, which had become detached to the point of being on the verge of collapsing, could only be done using swabs moistened in distilled water, which were rested on the surface for the (very short) time required to remove the grime without affecting the film of paint; indeed, it was a miracle that this film had miraculously survived earlier restorations. Cleaning the Pinturicchio fresco in Siena was the clearest demonstration of how easy it would be to ruin a painting, altering it forever.

It confirmed that I had good reason to be anxious about cleaning the *Pietà*, and in addition I was now torn between the wish to take charge of the work in Siena and the desire to leave for Buffalo. Manuela came to my rescue by offering to plan the work so it would not get in the way of the trip to America. She would have been entirely within her rights, as my business partner, to impose a programme that suited her; but she was as excited about the research as I was, and she has always gone out of her way to help me, as many other restorers have. The first thing was to solve the most pressing matter: finding an extraordinarily reliable collaborator who would come to America with me.

It is an unfounded myth that the creative professions are more given to gossip and backbiting. Among professional art restorers this is certainly not the case. Opinions are always well founded; and I had heard many speak highly of Lorenza D'Alessandro, a friend of Manuela's at the Istituto del Restauro in Rome, and of her particular talent for restoring sixteenth-century panel paintings. I had a vivid memory of her black hair and even darker eyes from the time when she had attended a course at my old institute, two years ahead of me. Even then she had been the most gifted pupil and a favourite of our beloved teacher, Laura Mora. Lorenza also had the

advantage of having US citizenship, and this had prompted her to work for museums and collectors on the other side of the Atlantic. As a result, she was very familiar with the materials and techniques used in old nineteenth-century restorations in the States.

By now it was clear that the painting had been restored as soon as it arrived in America, perhaps to repair damage suffered during the crossing. Grimm described it as untouched, and we had no reason not to believe him. I was certain that the repainting I had seen would not have escaped him. What was more, he had seen the panel one hundred and fifty years earlier, when the varnish would have been less yellowed. The first surviving photo of the painting, which, according to Martin, dates back to 1885 or was taken just after it had arrived in America, shows abrasions on Christ's head and on the shaded part of the Madonna's face, where I had seen the retouching. In this sense Grimm's declarations and the first known photo of the painting agreed. The panel had been in excellent condition, until some of the paint had come off during the voyage. If a careless restorer – and this profession was undoubtedly in its infancy in nineteenth-century New York – had not tried to hide those abrasions, adding to the damage by clumsily painting over them, the panel would not have needed any restoration. For this reason, it was fitting that the new restoration should be carried out by someone with expert knowledge of the materials used in America in the nineteenth century.

Lorenza was the right person. I had last seen her in Egypt in 1992, when I went to visit the team led by the indomitable Laura Mora, who was over seventy at the time, and by her husband Paolo, another extraordinary teacher, working on the restoration of Queen Nefertari's tomb in the Valley of the Queens. Since then we had bumped into each other at a few

social gatherings, at the Associazione Restauratori d'Italia – an organisation whose name has a faint Risorgimento ring to it, although in fact it was founded in the mid-1980s to raise government awareness of the need to safeguard Italy's artistic heritage, which is being inexorably destroyed by new laws. When we met, I was not surprised to find her in great shape. Indeed, as in the case of many other women, she was clear proof of how a passionate interest in your work and the enjoyment of doing something you have always loved can have a beneficial, almost magical influence on the body. The physical hard work usually associated with builders is very similar to that of art restorers: not only because of the scaffolding, which can be hard to climb, and because we have to carry all sorts of weights and objects all year round, but also because the manual work involved allows no excuses or exceptions and anyone who chooses to work in restoration must be ready to tackle its material aspects. This may explain why restoration remained, above all, a man's job until the seventies. But with Women's Lib, art restoration became one of the most sought after professions for many women. The reason, cynics might perhaps say, is that restoration and conservation are just a transposition in aesthetic terms of the maternal instinct that is stronger in women, the instinct to take care of people and objects. All this helps to explain why, when I saw Lorenza again after an interval of ten years – and nearly thirty since we first met – she was still as beautiful and energetic as when we had been at the Institute together. Now she was hard at work among the rubble left after the earthquake in Abruzzo, busy recovering fragments of art works, many of which she had restored years earlier.

We met one afternoon in my office. I showed her the painting and the diagnostic images on the computer. Long before I had finished sketching out my ideas about the autograph, she

had assessed the quality of the painting with enthusiasm. She examined the radiographic images carefully and made a diagnosis that coincided with my own, adding a few points I had missed. She had also brought her own computer and was able to show me some of the most important sixteenth-century panel paintings she had restored: they included works by Raphael, Sebastiano del Piombo and, to my surprise, even Venusti. His painting, entitled *Orazione nell'orto* [*Christ Praying in the Garden*], came from a private collection and was much more beautiful than the copy I had seen at Galleria Doria Pamphilj. The work she had done for many private collectors had kept her out of the media spotlight, working in a more self-contained and discreet capacity. Instead it had provided her with a range of experience that few can claim in Italy. However, her greatest gift, or so I thought, was the freshness with which she spoke about the new intervention techniques and the importance of continuous professional development. One of the most commonplace faults of experienced restorers is that they are convinced their way of doing things is right, and they bitterly resent any criticism. This attitude is widespread in manual professions, encouraging laziness and resistance to change. It is the most insidious gift of ageing. Lorenza was the ideal partner, and although we had never worked together she immediately agreed to accompany me on the trip.

When we met in Rome at the end of June 2009, Lorenza had already arranged a trip to Minneapolis with her family in order to collect her daughter's American citizenship papers. For this reason she suggested she would join me in Buffalo in early September, flying directly from Minneapolis. Then, having taken one look at my untidy office, she offered, like a true fairy godmother, to organise the transport of all the materials and equipment needed for the restoration. She told

me with a laugh that it would not be the first time her ample travelling beauty case had smuggled in solvents disguised as face cream. Even the ferocious US customs staff lacked the nerve to challenge the arcane necessities of a woman's cosmetic regime. Martin had undertaken to provide the rest of the equipment and a working space.

When September came, I felt quite at home in the lobby of the Seneca Casino. Not even jet lag could overshadow the positive tension and energy which I realised that Lorenza was feeling too. She had been in the States for twenty days, and I, barely for three hours. When we hugged, I knew she would play a decisive role in the mission. We called it a mission not in response to some vain Hollywood urge, but because, at the Institute we had both attended – that mix of college and workshop we loved so much – every restoration job outside the Borgia palace was referred to as a 'mission'. A few minutes later Martin arrived, his face wreathed in smiles. In some way or other he, too, was on the same wavelength, although exactly how he did it is still unclear to me to this day. It may have been his proximity to the painting, to Michelangelo's metaphysical presence – but I would never have imagined that a former American jet pilot could be so adept at helping and supporting two bewildered Italian restorers who had flown to Buffalo for an undertaking that scared them stiff, even if they would never have admitted it.

We had a wonderful dinner at one of the many restaurants in the casino. There was plenty of wine and growing affection: we were already cementing our alliance, without even having had to propose it. In Lorenza's company I found it easy to make my way around the casino – unlike the first time, when it had seemed so bewildering. I was reassured by her fluent English. There was no doubt about it, I had made the right choice. That it was a female colleague who was helping me

was not surprising: there is not a single event in my life that has not been facilitated, assured, or sometimes basically made possible by a woman. Lorenza even agreed to wake up at five the next morning to help with calming the anxiety I would have felt, alone with my thoughts and my unadjusted body clock. In exchange, I promised we would make a quick visit to the Falls before driving home with Martin, to start work in the small laboratory he had set up there.

20

THE RESTORATION

It might have been a coincidence, but Martin had booked me into the same room as before. Once again I was up before dawn, standing in front of the window on the twentieth floor, which overlooked the river and the Falls. I watched as the neon lights from that strange frontier city, devoted to entertainment, faded into the distance along the flat horizon. The milky cloud hanging above the Falls rose slowly, its changing outline blending into the brightening sky. The coffee shop in the atrium was closed for a short break between four and six in the morning. At a quarter to six I sat down in the restaurant opposite, where I was served breakfast by a Native American waitress; she was extraordinarily alert given the hour, on the cusp between night and day. Lorenza put a large red beauty case on the table, and beside her was a trolley bag into which she had packed an entire laboratory, complete with an electronic microscope used to analyse paint films at a level of magnification well beyond the ability of the naked eye. I had a

hard time persuading her that I had really meant it when I promised to accompany her to see the Falls before starting work.

From the banks of the Niagara we then drove to Martin's house a few kilometres further north and well upstream of the Falls. We walked into the garage, which doubled as a well-equipped workshop. We scanned the shelves, reassured by the presence of every single tool we could possibly need during the task ahead, because, for reasons undetected so far, restoration often seems to involve using the most unexpected devices. The bow window in the sitting room opened onto a perfectly mown lawn, as lush as an alpine pasture in June. Beyond the lawn and the silver fir trees lay the broad and peaceful river.

Martin immediately offered to get us coffee from the nearby Starbucks. He went on to explain how lucky he was: in a town that stretched out, ribbon fashion, for kilometres along the river, some houses were anything up to a hundred metres from the nearest shop or bar, while he was only a short walk from the best coffee shop in the area. Lorenza and I both accepted. She started to empty her beauty case, lining up dozens of sealed plastic bottles on the table which Martin had covered with a double layer of waterproof protection.

The familiar smell of solvents filled the room, as reassuring to us as the scent of baking from your grandmother's kitchen. Both of us found it relaxing. We sat down to scrutinise the painting once again in careful detail, comparing it with the reflectographic images on our laptop screens. Martin also had a much larger computer in his office, which he said we could use for close-up details. It was the first time I had ever used an electronic microscope of the type Lorenza had brought. I could see sharp images of the paint film darkened by a layer of filth, like mud coating the rocks along the riverbank after the floodwater has receded.

We started to carry out a series of cleaning tests, wrapping wads of cotton wool round the tips of small wooden skewers. First we soaked the swabs in alcohol, to remove the most recent layers of varnish, and then in a 3 per cent solution of tri-ammonium citrate – a base known as 'artificial saliva'. This rather disgusting name gives a good idea of the innocuous nature of the mixture. It has been available commercially ever since a group of scientists decided to manufacture 'saliva' synthetically, but for centuries restorers used to resort to a simpler, natural method of production. Of all the armoury of solvents, this is the weakest base available, with an efficacy to match; but it does guarantee utmost respect for the paint film. An old oil-based film is difficult to remove even if you use a stronger base, like an ammoniac mixture. But in art restoration it is always wisest to start low; you can always raise your game later. We were both silently hoping that the 'artificial saliva' would work. It would have been fantastic to be able to clean the painting by using such a light solvent.

Lorenza wanted me to clean the first 'window' on the Madonna's green mantle. It looked oddly out of place because it should obviously have been blue, but we suspected the colour had been altered by the yellowing varnish above it. Martin had just come back. He left the coffee in the kitchen and came to stand behind us. He was as quiet as possible, but we found his presence distracting. We were both staring at the minute swab in my hand. Within a few seconds, it had turned from white to cream, then to grey, and finally to black. It was as if the Madonna's knee had been illuminated by a ray of light, turning a brilliant sea blue. Shrieking with delight like two children, we jumped up and hit high fives, just like our 10-year-old sons. Then we hugged each other. Martin looked on, smiling in amazement and happy that things were going well.

It was difficult to explain to Martin exactly what that black swab and the luminous patch now visible on the Madonna's cloak meant, and we certainly did not want to frighten him. We had brought various kinds of solvent, including the strongest and most aggressive ones, which could only be used with all the windows open so as not to get ourselves intoxicated. However, we had hoped that the weakest tri-ammonium citrate solution would work. Apart from its horrible commercial name, it was harmless enough to drink. Now we knew that we could work wonders without any risk of damage.

At long last, the painting was materialising before our eyes: not the cracked surface of varnish and lampblack, but the real painting. The blue of the mantle was still veiled by a transparent patina, which many would have removed, to return the mantle to its original colour. However, we chose to leave it because, without even discussing the matter, we saw ourselves as belonging in a tradition with a sensitivity to and respect for the precious painted material, including its slight transformations.

Above all, we were happy because, from that moment on, we would be the first to see the unveiling of one of the greatest masterpieces of western art. Working in these extraordinary conditions, far from Italy, close to the river, surrounded by the northern light outside and by Martin's kindness inside the house, all that I – and Lorenza, too, I am sure – had imagined as being impossibly difficult now seemed an absolute privilege. Even the separation from our families seemed appropriate, because we could focus exclusively on the work. Having made the choice to spend our lives with works of art, in one way or another we felt part of their destiny and, rightly or wrongly, the unworthy continuators of the artist's work. For us, this was a unique moment. It felt like an indescribable and wonderful honour. Overcome by emotion, I shrugged off

the unhappy thought that this moment, this day would pass. It is a thought that arrives, inexorably, every time one experiences a moment of complete happiness. Only an instant later, however, it struck me that I would eventually write about it, and by telling the story I would relive the moment.

At that point I stood up again, just as I had done in the Vatican Library, and lit a cigarette. Martin was horrified: no one had ever done anything of the sort in his house. Then I sat down opposite Lorenza. She started with the right-hand angel, while I focused on the left-hand one. Next she moved to the Madonna, while I worked on the figure of Christ. Then she did the sky, and I cleaned the open grassy space at the foot of the rock. By three in the afternoon, Martin almost had to tear us away. He made us get up and sit on the veranda, to eat the sandwiches he had prepared.

'It's the most beautiful day so far this summer,' he said, starting the conversation. 'We've had cold rainy weather until yesterday. We'd given up all hope. But today the forecast is for a whole week of good weather.'

The river sparkled in the sunlight. A group of boys had climbed onto what looked like an old weir, set slightly back from the bank, and they were diving in between the boats that floated downstream as their crews laughed and clapped noisily at the display. Martin explained that, in this context, the word 'floating' describes the way a boat glides when its engine is turned off. If it had not been for the Bermuda shorts worn by the boys, we might easily have been watching a scene on the Seine a century earlier, of the kind that had enthralled Seurat or Cézanne. Lorenza and I looked on in silent exhaustion. We could hardly wait to get back to the worktable inside. The sandwiches were delicious: roast chicken, salad and cheese, and Martin had respected our special plea not to add any sauces. We had been working on the painting without a break

since seven that morning. We were like two concert musicians, two ice-skaters, two fishermen pulling in a long net. Martin could not believe that this was the first time we had ever worked together.

The institute in Rome that had formed us as equal partners has been likened by many to the ultimate Renaissance *bottega*: a workshop that forms taste, awareness and manual skills. Just like the workshops of Ghirlandaio, Perugino and Pinturicchio. This is why Michelangelo sought out artists who had been workshop companions when he embarked on the challenge of the Sistine Chapel. Without realising it, I had done the same, even if the comparison was disproportionate in terms of the value of our respective undertakings.

That day we revealed the radiant colours of the garments. The yellow and the madder lake of the angel on the right; the aubergine purple of the one on the left. The light that cast the shadow of Christ's reclining head onto his lifeless arm, and that of the Madonna's open arm, placed onto the forehead of the angel in purple. Christ's anatomy gradually emerged from beneath the grime, soft and still lifelike. Yet the colour of death gave a stiffness to his body that separated his flesh from the glowing complexions of the angels. Above all, it was an enormous relief to discover that the lacunae in Mary's open mouth were just pitch stains and could be removed without too much difficulty. We lightened the repainting on her eyebrow and on the shaded part of Christ's face, but stopped short of removing them altogether. Restoration must make the painting legible, but it must avoid altering it. We wanted other experts to see a work that was as integral as possible. We even avoided the normal practice, used in every restoration, of retouching the paint, and instead limited ourselves to filling in those gaps that created a sense of imbalance: one at the bottom of the painting, one on Christ's foot and another on the Madonna's chin.

'What an extraordinary painting. There are few other occasions when I've worked with material like this. It's so beautiful, so strong.' Lorenza spoke quietly, without even looking up from the painting. 'There are small abrasions, but the paint film still has its patina. Nowadays, that's a real miracle. It's a stroke of luck that it's been hidden from the public eye. It was removed from almost all the sixteenth-century panel paintings that were cleaned in the nineteenth century, and even last century I have to say, in an attempt to reveal their brilliant colours. Just look at that shade of blue on the Madonna's cloak. It's so delicate. And do you see how the folds turn so beautifully? It's like touching velvet.'

I was entranced by other details. 'Have you seen this angel's feet, the one on the left? They look just like the painting in the Pauline Chapel. It's so lucky that I was there, on the scaffolding, only two months ago. The back foot is painted with such speed and softness that it looks blurred compared to the sharply detailed front foot. In his later years, Michelangelo always used this device of blurring the figures in the background.'

Behind us, Martin was filming the work with a video camera and trying to hide his disappointment at not understanding a word of what we were saying. When he heard the excitement in our voices, he asked us, with a large smile, to explain what we had seen. 'Do you see this minute brushstroke of light glancing off the angel's eyebrow?' I asked. 'And here, look how this toe is barely lifted off the ground. Can you see how the light is reflected under the tip of the nail?'

At other times it was Lorenza who spoke to him, in much better English. 'Do you see how the light is drawn to the fabric of the Madonna's blouse, on the right arm? The artist uses it to isolate her bust and at the same time to create depth. Look, you could almost put your hand inside the space. The

same thing happens to the light that falls behind the angel's head on the right. It illuminates the shoulder and gives an amazingly three-dimensional quality to the head.'

Martin bent closer and tried to bring these details into focus on the camera. 'It's hard to believe that it's so small, even when you're working on it,' Lorenza continued. 'Each detail is only a few centimetres wide, yet it contains so much painting. The Madonna's face seems to have been carved with a chisel. It is so physical, so statuesque, but at the same time so intimidating. You can't escape from her pain. What is really extraordinary is the type of paint that has been used. It's very even and flows off the brush, but not to the extent that it loses any of the full-bodied colour or brushstrokes. There are some transitions that are so gradual they remind me of the Dutch artists. But the density of the light and the brushstrokes are also reminiscent of Florence – of Bronzino, for example, although he is a bit too stiff, too stylised and cold in his anatomy, and his facial expressions are rather haunted. He's a real Mannerist who imitates Michelangelo.'

'Yes,' I said, 'try explaining that to Martin.'

Then in the late afternoon, when we had to turn on the lights to continue working, a white flower suddenly emerged from the grime at Christ's feet. We were so tired and so satisfied that at this point even the most sentimental language seemed appropriate. But we were also determined not to let anything spoil the beauty of that moment. Even in this near exhausted condition, I made a stab at a rationalised, more academic approach, bearing in mind that I would have to write about it and convey its intensity. 'It's reminiscent of the *giglio*, the lily. I think this white flower evokes the lilies that Netherlandish artists painted at Christ's feet in every *Pietà* or *Adoration*, to symbolise Christ's purity. It also recalls the white flowers that Fra Bartolomeo scattered at the feet of his

Sacred Families. He was imitated by nearly every Florentine artist at the time who tried his hand at sacred painting. It's just a memento, a light touch: six white brushstrokes against the dark background; yet it's enough to conjure up an entire universe of figurative painting. Michelangelo was old enough to remember this vogue for devout lilies and symbolic flowers at its height. Florentine art was full of them.'

Lorenza's approach was more concise and more reasoned. 'I know where I've seen it: it's like the white flower Sebastiano painted in the Viterbo *Pietà*. In any case, that *Pietà* was drawn for him by Michelangelo. It explains this Madonna's face, too. It's so strong, almost male: she's the twin of the Madonna in Viterbo. Well, on second thoughts, here she is much more maternal, more feminine. Del Piombo turned the Viterbo Madonna into a man. I had to carry out some emergency work on that flower once. In fact, I'm sure I've got the enlarged photos in the office.'

'Have you also worked on Doni *Tondo*?' I asked. 'Look, I've found some grasses that are absolutely identical to the Doni *Tondo*. These clumps of couch grass here, for example. A few light brushstrokes and there it is, a little tuft that breaks up that desolate expanse of red mud.'

Lorenza said: 'Do you really think he would have drawn the same grass forty years later?'

'If you'd seen the number of faces on the Piccolomini altar that are exactly the same as those on the *Moses*, you wouldn't even ask. Believe me, the Master always repeated things. With some differences, of course, but in the case of apparently unimportant details, like the grass, there was a natural tendency to do them the same way. It's rather like handwriting, he never really felt the need to change these things.'

'All right,' replied Lorenza, 'and what if I show you this clear outline of a cloud that's appeared in the sky? Is this

another memory of the Viterbo *Pietà*? But that was only ten years earlier.'

Instead of answering, I stood up to stare at the black swab that Lorenza was circling lightly over a curved white line, the outline of a cloud in the dark and fathomless night sky. The start of a night of terrible pain, which held the Madonna in its grip. The two angels lacked the courage even to look at her or at the livid corpse sliding off her lap for the last time, gone forever.

21

PENTIMENTI

We ate around nine o'clock, again on the veranda. Martin treated us like two kids, back from a long and exhausting camping trip. A woman brought us an almond cake, which was apparently an Italian recipe and had been made for us by an Italian friend. I could barely keep my eyes open: it was already early morning Italian time, but when we returned the hotel was still buzzing. Lorenza and I stopped to watch the frenetic activity around the gaming tables. We sat at the bar for a nightcap. The risk of being so tired is that you can easily fall prey to anxiety. We had both found it incredibly hard to leave the painting. And for what? Just to sleep. But, as parents, we both knew that children need to sleep before they have a chance to get overexcited. It's dangerous to work when you are collapsing from tiredness. What we needed was a whisky, a brandy, and two cigarettes. We went on thanking each other like two idiots! Luckily no one could understand us, and that made us laugh.

Beside us was a man who had just emerged the worse for wear from the gaming floor. He topped up his glass from bottles he was clasping in a plastic bag on his lap. We raised a glass to him and, when we wished him luck, we meant it. Then we said goodnight and went to bed, watched over by the cloud of white mist from the Falls.

The next day was much more relaxing. Most of the work had been done and the risk of making a mistake was behind us. All we had to do now was to explore the work with a fresh mind. Lorenza was the first to notice something while she was finishing the bottom of the painting. I had brought Bonasone's engraving with me, a clean copy taken from the copperplate engraving in Rome. As she looked at the green and brown glaze covering the bottom of the painting, Lorenza stopped and asked me whether she could see the engraving. I went to fetch it from my bag and then turned on her laptop, so we could also see the infrared reflectogram from Buffalo. I started to enlarge it, focusing on the area in the bottom right-hand corner which Lorenza was cleaning. At least once in a while every restorer has felt, or perhaps secretly longs to feel, like the lead actor in Antonioni's *Blow-Up*, who discovers a crime by enlarging a photo to make it reveal details that the naked eye has missed. I sat and waited, leaning back in the chair and trying to relax.

'Look, there it is. Good grief, there it is. The grass on the right edge of the rock.' She pointed to the painting and then to the reflectogram. I looked, but, as far as I could see, there was nothing there. Martin had moved away without saying anything. He knew we had to explain things to each other first, before we could attempt to elucidate them to him. After spending a lifetime with the painting, it must have been strange for him to discover how many aspects of this familiar object had been hidden from view.

'Look closely at the engraving. Do you see? There's a clump of grass on the right. Michelangelo painted it and then, later, he covered it in order to raise the horizon. You can feel the relief of the blades of grass under the brown glaze. And here,' she continued, 'look at the reflectogram here! You can make out the painted grass perfectly.'

I had looked at that image for a whole year. I had enlarged it, scrutinised every detail and spotted some new ones. But it was only now that I saw the grass on the rock. It was like a footprint, but clearly visible. The brown glaze followed the outline of the grey rock, passing through the open fingers of Christ's left hand. Originally, the horizon had run behind his hand, as the engraving showed. It was like opening a secret door onto another painting. One after another we began to see details that had initially formed part of the artist's design, only to be changed during execution, as he corrected the shortcomings and weaknesses of the underdrawing. But what was truly extraordinary was that Bonasone's engraving documented, rigorously, the first version of the painting. No study had ever shown anything like this before.

For at least fifty years, these so-called *pentimenti* or artist's changes have been used to distinguish original works of art from copies. Clearly, a copy cannot, by definition, contain *pentimenti*. The copyist does not create, he only reproduces what others have created; he starts from a precise image, which his copy seeks to imitate in every way. *Pentimenti* have been used to reveal the authenticity of works by Caravaggio and Rembrandt, two of the most frequently forged painters in art history. But now Bonasone's engraving was showing us something more. The date marked on the rock, 1546, confirms without question that the engraving was made that year. Similarly, the letter from Bertano to Gonzaga shows without doubt that, by 1546, the painting was no longer in

Rome. Cardinal Pole opened the first session of the Council of Trent with a solemn address on 13 December 1545. Therefore it would be reasonable to suggest that he arrived there, with the painting, in late November. I had surmised, for these reasons, that Bonasone must have made his engraving using the preparatory sketch drawn by Michelangelo for the painting. This would also explain the accuracy of Bonasone's copy.

However, the detail Lorenza had discovered, which rapidly proved to be only the first in a long series, showed that Bonasone's engraving had immortalised the first version of Michelangelo's idea. It was an idea that the restless artist had subsequently changed, using a procedure common to all of his works from this period. The restoration of the Pauline Chapel has even revealed Michelangelo's propensity for adding new figures while he was actually working, sometimes after the plaster had already dried. An example of this is the last figure above and to the left of the Cross in the *Crucifixion of St Peter*: this unplanned addition was painted half onto plaster that had already hardened and half on an adjoining patch of fresh *intonaco*, by using a normal fresco technique.

In the case of the *Pietà*, this fact also gave new meaning to the evident *pentimento* on Christ's face, the one that had immediately become visible in the reflectogram of the painting. Christ's original profile was more foreshortened, as is shown in Bonasone's engraving. The lock of hair that hangs in a ringlet, creating a triangle of light between the cheekbone and the shoulder, was initially drawn as it appears in the engraving – where, it has to be said, it is not wholly convincing – but in the painting Michelangelo had changed his mind. As a result, he had widened the right-hand side of Christ's face, painting over the triangle of light. The same had happened to the end of Mary's veil, which is draped over her

head. Under the paint, the reflectogram showed that the original design coincided with the engraving. Likewise, the right-hand side of Christ's chest, which revealed a misleading double perspective in the drawing, had been adjusted appropriately. The feet of the angel on the right had also been cleverly corrected. In the engraving, the right foot is too far behind the left, meaning that the heel should be visible. Its absence makes the foot look deformed. Originally this was how it was painted, but Michelangelo had then narrowed the angle, making more of the back foot visible, with the result that the heel could now legitimately be concealed by the ankle of the foot in front. Even the band across the Madonna's chest, which in the painting looks odd because it does not encircle her as it does in the engraving, was originally drawn in full; but the desire to widen the tunic to give solemnity to the Madonna's bust had prompted Michelangelo to paint more of the garment beyond the end of the band. By shading the area, he had hoped to make this oddity less noticeable.

By late afternoon we had pieced together nearly all the changes made by the artist while painting. We had even discovered an unfinished portion, almost as if Michelangelo had left his signature on the painting. After cleaning the grime off the rock, the outline of the underdrawing emerged; it was a portion that had been visible in the reflectogram, but difficult to interpret. Now the sharp black profile of the rock stood out from the red ground that served as the grassy base. In the foreground Michelangelo had transformed the ground into a meadow, using rapid brushstrokes to create a series of small plants. But, on the left, the outline was still visible where the artist had not bothered to complete the rock. This proved not only that Michelangelo himself had painted the *Pietà* but, moreover, that he had not allowed anyone to touch it, not

even to finish it. He was all too familiar with the consequences of involving others in his work. As may have happened in the case of the Oxford *Crucifixion*. It was not only the quality of the painting that marked it as the Master's autograph. Leaving aside this intangible aspect, subject to the whim of individual perception, its autograph nature was borne out by a creative process that clearly excluded any possibility of the painting being a copy, even by an albeit gifted artist. The Ragusa *Pietà* had been conceived on the panel, through the hand of an artist who had created and perfected its composition at the very moment of its realisation. Only the inventor of that composition, Michelangelo Buonarroti himself, could have made so many variations and improvements to an idea that was already extraordinary by its very nature. Venusti's copies, on the other hand, proved how even the most talented copyist, a man close to Michelangelo, could never even dream of achieving the expressive power of this painting. The x-ray images of Venusti's *Pietà* had also shown how the process of copying was extremely mechanical.

For Lorenza and myself, accustomed as we were to handling paintings and analysing their qualities, there could be no doubt as to the autograph nature of the painting. It was a conclusion we would have reached even without the impressive array of documents ferreted out from archives and libraries across much of Europe.

As we sat on Martin's veranda at sunset, a few metres from the shining river in whose green water boys were still splashing, elated by the beauty of this rare summer's day, I watched Lorenza as she explained all this to our host, without even a word of jargon. Where did she find the energy? Martin was in seventh heaven. At long last, he could demonstrate what he and his family had always known and asserted. He hung on Lorenza's words, turning to look at me occasionally with a

happy, unreserved smile. He could not understand why I was glum. Nor could Lorenza.

'What's the matter, Antonio? Aren't you pleased? You were right. It is a Michelangelo. It's a sensational discovery. I'd go further than that: it's the *most* sensational discovery ever made in art history. And what a story: Ragusa, the *spirituali*, the Inquisition. It could have been concocted by Dan Brown.'

'That's the problem,' I replied.

As soon as I reached the end of this adventure, which had led through the sweet pastures of art as we retraced the story of this extraordinary painting, the slow but unstoppable realisation of what lay ahead came flooding back. Above all, I was imagining what lay ahead for me. 'How on earth will I tell the international community of art historians that for centuries they've ignored one of Michelangelo's most important masterpieces because of their stubborn, blind and wholly unfounded faith in Vasari?'

'But no one doubts Vasari's mistakes any more,' burst out Lorenza. 'Everyone knows he wrote a load of rubbish on occasions.'

'Yes, of course they know that, in theory. But in practice the leading twentieth-century art historians pronounced judgement on this particular question, with the result that Vasari's mistakes have been set in stone. Demonstrating the existence of these paintings means revealing the devastating power of prejudice precisely in those circles whose legitimacy rests on the ability to exercise critical discernment. Believe me, it won't be easy.'

'But what about the documents? And then there's the painting itself, the infrared images, the x-rays,' she added. 'There's more stuff about this painting than about many that are happily attributed to Michelangelo and on display in leading museums worldwide. Think of *The Entombment* at the

National Gallery in London, or *The Torment of St Anthony*, which recently went on show at the Met, or even the Boston drawing of the *Pietà*. Not to mention that wretched wooden *Crucifix* that Sandro Bondi's just bought.' Turning to Martin, Lorenza added: 'He's the Italian Minister of Culture, you know. Yet no one even knows where this *Crucifix* came from!'

It was Martin who found the words to reply to Lorenza. It was clear that even his unshakeable American faith in the truth had been severely tested during the long years when he had confronted the prejudice and the unchallengeable authority of the international academic world. He turned to face me, shaking his finger disparagingly: 'Some of the highest ranking experts didn't even want to *see* the painting because they were so adamant it couldn't possibly exist!'

The rest of the story is still waiting to be written.

EPILOGUE

When the research reached its first reliable conclusions and the torrent of excitement that had swept me along for three years shrank to more manageable proportions, thanks in part to writing the account you have just read, I started to prepare a formal scientific presentation. I wanted to share with general readers the feelings that accompany a major discovery in the field of art history (major, that is, for me, of course), but at the same time I did not want to give up the idea of communicating the results in a more rigorously scientific report addressed to the academic world. I started to sort out the material I had amassed and to shape it into a comprehensible form, a precise scientific hypothesis.

I began by analysing in detail the relationship between the original paintings I had traced in America and England and the engravings that had been made from them and were already known to experts, but thought to have been copied from Michelangelo's drawings, not from his paintings. There

were no printed copies of the *Crucifixion* that had belonged to Tommaso Cavalieri, only painted ones. Indeed, this fact has often been used to support the theory that Michelangelo only made the drawings, while another artist close to him, perhaps Marcello Venusti, independently translated these drawings into painted form.

On the contrary, various engravings exist of the *Pietà* for Vittoria Colonna. The one that is closest to the painting discovered in America is a print engraved by Nicolas Beatrizet in 1547. Indeed, unlike all the others, Beatrizet's engraving includes many details that could only have been copied from the original painting or from the drawing which Michelangelo prepared for it. One detail in particular had attracted my attention: inside Mary's open mouth, a row of teeth was clearly visible in that grimace of despair. This was a vital clue, which was not present in the other engravings and was only hinted at in the painted copies I had seen. If Beatrizet had given such prominence to this unusual, almost unseemly detail in the iconography of the Virgin, it meant that he had fully grasped the significance of its presence in Michelangelo's autograph painting.

The available reproductions of this relatively small engraving (it only measures 37.5 × 26.2 cm) were not sufficiently clear to allow me to be sure that those teeth really existed, and so I decided to go back to America, to New York, to see the only known original of the *Pietà* engraved by Beatrizet. As I thought about the journey, it struck me that almost everything concerning this painting had decided to migrate across the ocean.

I arrived in New York in early December, to find the city sparkling with ice; the glass-fronted skyscrapers seemed even more dramatic, more showy than the gold-dusted models in the majestic store windows on Fifth Avenue. I left the hotel on

West 81st Street at ten in the morning to walk across Central Park, where the maples were still coloured with the last of the bright autumn leaves. As always, I was torn between the beauty of the scene, which never fails to surprise me, and the desire to get to the Metropolitan Museum. The folder containing Beatrizet's engraving was waiting for me on the study room table. I had not expected to find a room like this: it was just the same as the countless European reading rooms housing fine old drawings. Everything that was insolent and feisty about New York, its unreal beauty and modernity, was stopped in its tracks at the threshold of the study room for drawings and prints at the Metropolitan Museum. Inside, the atmosphere was permeated by the eternity of time, captured in those prints and drawings, without the need for ostentatious leds and lights bright enough to rival the sun.

Three women of different ages moved in perfect silence around the shelves, looking exactly like their counterparts in the print rooms of Paris, Rome or Athens. I pulled out my professional opti-visor, more to give myself some semblance of standing rather than anything else. I also got out the pencil I had just bought on Amsterdam Avenue, in the certain knowledge that, even in New York, only pencils, not pens, would be allowed in the study room. Although the room was empty, the young woman whispered as she opened the folder containing Beatrizet's engraving; perhaps she feared we might otherwise have disturbed the drawings in their cardboard loculi. My gaze was immediately drawn to the mouth and, even without the visor, it was clear that the engraver had intentionally made the teeth visible. Here was further confirmation of the painting's authenticity. Those teeth could never have been so clearly drawn if Beatrizet had not personally seen proof, either in the painting itself or the drawing used for it, that Michelangelo had portrayed Mary in human

anguish. These teeth were not present in any other copy I had seen.

Shortly after 1560 Cardinal Borromeo had given very detailed instructions to painters about how they should portray the Virgin, thereby achieving the Counter-Reformation Church's need for strict control over sacred images. In accordance with his aims, Mary's mouth had to be slightly open, as if she were whispering. Utterly unlike the heart-rending cry that Michelangelo had painted, coming from a woman who was so physical, so un-divine that she might have come from the streets. It was this feature that Beatrizet had managed to capture so sharply in his engraving. In the end, these observations were accomplished so simply, and so rapidly, that I almost felt I had overreacted by crossing the Atlantic just to see this drawing. I felt slightly guilty for having wasted time and money on a trip that had been nothing more than an overexcited attack of investigative zeal. Half an hour later, I had seen all I needed to; moreover, I had ordered a high-resolution photograph that would enable me to enlarge and publish that detail at the lecture I was giving at the Accademia dei Lincei in Rome a few months later. Now I could dive back into New York's pre-Christmas delirium, and for two whole days I would be free to tramp the streets until my legs ached.

It was almost out of good manners that I decided to stay a little longer in the drawings and prints study room at the museum. The staff had been so quick to give me an appointment and to bring the engraving at the right time that it seemed an affront to their professionalism to leave after barely half an hour.

To salve my conscience, I asked if it might be possible to see other engravings by Beatrizet and apologised for not having sent the request in advance. The young woman turned

to look at the others questioningly. Although seated a little
further way, where they seemed engrossed in their work, they
had heard my request. They walked into the adjoining room
leaving the door ajar. Then the oldest woman came back to
apologise for the time it would take to fetch the other engrav-
ings from the store where they were housed. She even offered
me a cup of coffee, although I barely had time to drink it
before two new boxes, each half a metre wide, were placed on
the table.

I lifted the heavy cardboard lid, turned over the first
engraving and froze in astonishment. Underneath was a copy
of Tommaso Cavalieri's *Crucifixion*. No one had ever seen it,
no one had ever published it, because it was not supposed to
exist. So strong was the conviction that the *Crucifixion* had
been composed by Marcello Venusti – and no one would ever
have made an engraving of Venusti's work – that the existence
of the sheet in front of me had never even been suggested. It
was a sensational discovery. However, even more sensational,
to my mind, was the fact that this engraving had not reap-
peared on the walls of some old Italian palace, but rather
among the towering skyscrapers that crowded the skyline out-
side the windows, soaring above the huge treetops of Central
Park, where clearly no one had ever dreamt of looking for it.
Not to mention that the catalogue of engravings made from
Michelangelo Buonarroti's works was assumed to have been
completed decades ago.

I realised immediately that the engraving had not been
made from the two copies of the painting in Rome and
Florence, but rather from the *Crucifixion* belonging to
Tommaso Cavalieri, because the level of Mary and John's
heads coincided with their position in the latter, while in the
two copies they were much higher. Once again, I found it
hard to credit the enormity of the discovery, and its

fortuitousness flew in the face of reason. I had come to New York to inspect the engraving of the *Pietà*, but instead I had been guided here to discover a much more important engraving of the *Crucifixion*. Moreover, this new engraving reaffirmed that the painting for Cavalieri was an autograph Michelangelo. Once again, I tried to rein in my thoughts by acknowledging that I could not possibly be the first Michelangelo specialist to see this engraving. Perhaps, I reasoned, it was simply that I had never seen it published in the repertoire on Michelangelo.

Taking time to gather my thoughts, I asked whether I could see the photo of the engraving, as I had just done for the *Pietà*. The young woman looked at me disappointedly and replied that there was no photo because none had ever been taken. So it was true. In my agitation, my command of English started to falter as I tried to explain the importance of that sheet of paper. The girl started to frown, and out of the corner of my eye I noticed that even the other two women were looking on in slight amazement. I stopped and decided to take a moment's breath. The best thing would be to make some comparisons, but I had left my laptop at the hotel. It would take me half an hour to cross the park and reach the hotel on 81st Street, but the walk would help to calm me down.

As soon as I was outside the museum, I rang my sister in Amsterdam. I was sure that, if the engraving had slipped my mind, she would undoubtedly remember it. But she had never seen it either. The squirrels stopped in their tracks, intrigued, when they heard me shouting on the phone. At the other end of the line my sister could not understand why, having left to see an engraving of the *Pietà*, I was now talking about a *Crucifixion* that was identical to the painting for Tommaso Cavalieri. It was difficult to explain that it was a completely chance finding, also because, frankly, it was hard to believe

that documents like this one, so precious to our understanding of the great artist himself, could be here in New York, so far from Italy and from the Renaissance archives. But, while I tried to resist the rhetorical temptation of seeing this finding and the path taken by these documents as an allegory for the 'brain drain' towards the freedom of a new world, the real reason for that journey began to dawn on me as I walked under the centuries-old elms framed by gilded towers.

The depiction of Christ Alive on the cross had been declared heretical on 24 August 1556, in a decree issued by Paul IV, the great inquisitor, and censorship would certainly have ensured that engravings like the one I had just seen vanished from the market. Indeed, only recently the news of this censorship had been a focus of debate among specialists in Renaissance history. After that decree, all the engravings made from Michelangelo's painting had been destroyed, like the books which the same pope had banned by placing them on the Index.

The engraving in my hands was the only known example, to date, that had escaped that wave of destruction. Its saving grace was probably the fact that it was already outside Italy when the decree was passed. It may perhaps have been taken to England or Germany, following the currents of renewed faith. Many wealthy American families originally came from England or Germany, and the engraving had finally reached the Metropolitan Museum through a bequest from one such family. There it had lain in its stores for half a century, escaping the notice of every Michelangelo expert. American scholars carry out their research in European and Italian archives and they certainly do not imagine that their own museums now house a vast amount of valuable material, which is often unpublished.

Whatever the explanation, the engraving of the *Crucifixion*

was a sensational finding, which helped to reconstruct the story of Michelangelo's painting. What was truly extraordinary, however, was that it had been found, like a seal of scientific approval, at the end of a lengthy research, which had succeeded in identifying the painting by other means. Yet I could already foresee that no one would ever believe the timing of these discoveries; indeed, the scientific community would all too readily suppose that finding this engraving had given me the idea of attributing to Michelangelo the painting from which it had been copied. The fact that I had no photo of the engraving generated an irrational and irrepressible sense of anxiety. The study room assistants assured me that they would immediately place an order with the agency that worked for the museum, but even the sparkling skyscrapers of New York failed to allay my concerns that bureaucracy follows its own perverse logic.

This was confirmed when I spoke to the agency that same afternoon: having walked to their offices in Soho, I was told that, because of various contractual agreements, I would have to submit the request for a photo through an Italian photographic agency based in Florence. There was no alternative. I felt that, once I left the museum, the engraving and everything it stood for would vanish into thin air. My fears were not entirely unfounded, because the photo of the engraving finally reached me three months later, on 3 March to be precise. That afternoon I made my way back to the museum in despair. I tried to explain to the staff that the engraving they had just finished cataloguing, in spite of having no photograph, was a vital piece of evidence. I also added that it was probably the only engraving to escape the censorship of the Inquisition. I cursed the haste that had made me leave Italy without a camera, because I would have been allowed to take a photo myself, purely for study purposes. I tried to focus and

to think rationally in order to note down as much information as possible.

I measured the cross and the Christ figure using a dressmaker's tape measure given to me by the oldest female assistant, who, seeing my desperation, clearly took pity on me. Any doubts regarding the autograph nature of both of Michelangelo's paintings had already been dispelled before flying to New York. But now I had found this engraving and, as I walked once again back across Central Park, hoping that the wonders of the city would temper the excitement of my discovery, it crossed my mind that my excessive zeal – which had brought me to New York so that I could personally check an engraving that was available in photo – concealed a secret logic and, why not, even a touch of magic. Those sheets I had seen and touched had been handled, admired and venerated centuries earlier by the devout admirers of Michelangelo Buonarroti, who had bought them. They were imbued with these people's emotions.

That an object can actually transmit emotions is a theory upheld in all seriousness by religions that count millions, if not billions of believers, but my rational mind will never yield to this suggestion. However, by the time I had reached the Plaza Hotel – whose Christmas decorations were garish enough to satisfy a child's wildest dreams – I was convinced that those sheets emitted an energy that had revitalised my research. Spanning the centuries, they inexplicably yet unquestionably brought me closer to the great artist and to his courageous visions; for an instant, like the glimmer of a firefly, a light shone through the darkness that still envelops the life of the tormented Florentine genius.

Rome, 14 March 2010